Postcard History Series

Morristown

ON THE FRONT COVER: This c. 1906 postcard by the Temme Company features a collage of images utilized in other postcards by the publisher. Beginning in the top left corner and continuing clockwise, pictured are the South Street Presbyterian Church, the Morris County Golf Club, the courthouse marker on the Green, Washington's Headquarters, and the Morris County Courthouse. (Author's collection.)

ON THE BACK COVER: This postcard, sent in 1905, shows South Street in the direction of the Green. One of the business signs visible on the left is that of the establishment of Heywood Glover Emmell, a Civil War veteran who opened a stationary shop. A number of postcards in this book were published by Emmell. The store also sold a variety of other items, including bicycles. (Author's collection.)

Postcard History Series

Morristown

Bonnie-Lynn Nadzeika

Copyright © 2012 by Bonnie-Lynn Nadzeika
ISBN 978-0-7385-9280-0

Published by Arcadia Publishing
Charleston, South Carolina

Printed in the United States of America

Library of Congress Control Number: 2012933075

For all general information contact Arcadia Publishing at:
Telephone 843-853-2070
Fax 843-853-0044
E-mail sales@arcadiapublishing.com
For customer service and orders:
Toll-Free 1-888-313-2665

Visit us on the Internet at www.arcadiapublishing.com

For Mom and Dad for their love and support, Michael for believing in me, and Suzanne Harper, who first encouraged my love of history

Contents

Acknowledgments		6
Introduction		7
1.	George Washington Slept Here	9
2.	Historic Sites	19
3.	The Gilded Age	25
4.	Downtown Scenes	47
5.	Churches and Schools	67
6.	Public Institutions	81
7.	Transportation	93
8.	Places to Eat, Sleep, and Drink	101
9.	Parks and Recreation	111
10.	Residential Streets	121
Bibliography		127

Acknowledgments

First, I would like to thank Carrie Fellows at Macculloch Hall Historical Museum for sending an e-mail that set this project in motion.

I also owe a debt of gratitude to the generations of historians who have worked to document Morristown's rich history. Many of them I have had the privilege of knowing, but many others I know only through their words. This book would not exist without their hard work.

For their help with acquiring images, I would like to thank the following: Randy Gabrielan at the Monmouth County Historical Commission, who sent me both postcards and advice; Ryan Hyman at Macculloch Hall Historical Museum; Melanie Bump, Lynn Laffey, and Chris Rain at the Morris County Park Commission; Peg Shultz at the Morris County Heritage Commission; Karen Hillman at the New Jersey State Library; Karen Ann Kurlander at the Morris County Historical Society; Miriam Kornblatt at the Morris County Library; Elliott Ruga; and Lewis Feldman. Thank you to Pam Hasegawa for her wonderful photographs featured in the current postcards. I owe a special thank-you to Carol Barkin at the Morris County Tourism Bureau for putting me in touch with Lewis Feldman and his wonderful collection. I purchased a number of cards at the Old Book Shop in Morristown, and I thank the owners, Virginia Faulkner and Chris Wolff, for their valuable input.

I would also like to thank the staff at the North Jersey History Center at the Morristown Library for all of their help in conducting my research. The Internet simply cannot replace the treasures still found at a local library.

Thank you to both of the editors I worked with at Arcadia Publishing: Abby Henry and Erin Rocha. You made this project a pleasure.

Finally, I would like to thank the Morris County and New Jersey history communities. They are unsung heroes who dedicate themselves to preserving the past despite all obstacles. I am honored by their friendship.

Images appear courtesy of the author. Additional images appear courtesy of Lewis Feldman; Pam Hasegawa; Macculloch Hall Historical Museum, Morristown, New Jersey (MHHM); the Morris County Heritage Commission; the Morris County Library (MCL); the Morris County Park Commission (MCPC); the New Jersey State Library; and Elliott Ruga.

Introduction

At first glance, Morristown, New Jersey, seems the same as any number of medium-sized towns throughout America. It has a center green surrounded by churches and retail establishments. Outside of the downtown area, residential neighborhoods intermingle with parks and schools. A major interstate highway bisects the eastern portion of town. However, if you open nearly any American history textbook, you will find a reference to Morristown. Whether it's 1776, 1848, 1912, or 2003, the story of Morristown is part of the story of America. Much of this history can be found in the hundreds of postcard images that document Morristown.

This volume treats Morristown and Morris Township as a single entity, which they were until 1865. The communities have continued to share certain services, and their history remains intertwined. Postcard publishers have never made a distinction between town and township, and in some cases, institutions in nearby communities were labeled "Morristown" despite what the lines on the map indicated.

Morristown began as a small settlement in the early 1700s known as West Hanover. The handful of residents traveled to nearby East Hanover on Sundays to attend the Presbyterian Church. By 1738, there were enough established households that the residents formed their own church. In 1739, Morristown became the county seat of the newly formed county of Morris, which had previously been part of Hunterdon County. When the Revolutionary War broke out in 1776, Morristown had two churches facing the Morristown Green, which was also the location of a primitive courthouse and jail. There were approximately 250 residents.

Morristown entered the history books for the first time in the winter of 1777, when George Washington and his troops came to town for the duration of the season. Morristown's location in the hills of northern New Jersey gave them protection from the British in New York while keeping them in close enough proximity to observe the enemy's movements. A small powder mill on the Whippany River was also a benefit. Washington stayed at the Arnold Tavern, and the local militia, Jacob Arnold's Light Horse Troop, paraded on the Green. Washington returned in the winter of 1779–1780, a harsh and difficult winter that was far worse than the more famous one at Valley Forge. During his second stay, Washington lived in the home of the widow of Col. Jacob Ford Jr. Many of his men stayed in nearby homes, and his troops were settled in at Jockey Hollow. The town had been home to both patriots and loyalists, but the latter either left town or were rounded up and housed in the small jail on the Green. When Washington and his troops left to fight the war in other colonies, they left an indelible mark on the town.

Its part in the Revolutionary War would have been enough to secure Morristown's place in American history. Yet just a few decades later, the small village entered the history books again when, in 1838, Alfred Vail demonstrated a new invention, the telegraph, at a factory building that was part of his father's ironworks complex. Although the telegraph seems like a simple machine now, it was the first in a line of inventions that led to the smart phones of

today. Sadly, Alfred Vail's name is generally lost to history, eclipsed by that of Samuel F.B. Morse, his older and much more commercially savvy business partner. In an interesting side note, Morristown became home to many early telephone pioneers, including Theodore Vail, a distant relative of Alfred and the first president of AT&T.

Morristown may have remained a small town with two footnotes in history were it not for the presence of another 19th-century invention: the railroad. The railroad also came to Morristown in 1838. Trains traveled from Morristown through Madison and across northern New Jersey to Hoboken. The route was nearly identical to that traveled by today's commuters and carried both people and freight. The railroad brought the town two distinct populations: millionaires and immigrants.

A few wealthy New Yorkers discovered Morristown in the mid-19th century. They acquired acreage and built homes and established gentlemen farms. They were able to enjoy the countryside and all it had to offer, while still being able to commute to New York City. By 1900, Morristown was home to one of the largest colonies of millionaires in the nation. Naturally, building elaborate homes was not enough. They also established clubs and organizations to keep themselves entertained. Both their homes and their clubs are richly documented in postcard imagery.

Any community of the wealthy must also have a serving class. In Morristown, first Irish and then Italian immigrants settled and worked as servants, gardeners, and construction workers. Jewish immigrants from a variety of countries opened retail establishments. African Americans also came, part of the northern migration that followed the Civil War. They joined a small population of free blacks and former slaves already established in the town. Few African Americans were servants for the ultra-wealthy, and most were unskilled laborers. Unfortunately, the history of these groups, particularly African Americans, is difficult to find in published images, particularly postcards.

During the 20th century, Morristown fell into an established pattern: growth and modernization conflicting with a desire to preserve the communities' rich history. By 1933, it was home to the nation's first National Historical Park, when the National Park Service acquired the Ford Mansion, which had served as George Washington's headquarters, from the Washington Association. Throughout the 20th century, a variety of groups started historical museums, all in an effort to tell the story of Morristown's past.

At the same time, business and residential districts continued to grow. Elaborate mansions were torn down and replaced with office buildings. A handful were saved as residences, others became home to schools or other institutions. By the 1960s, urban renewal, for better or worse, came to Morristown, forever changing the landscape as countless buildings were torn down in the name of progress. Fortune 500 companies built headquarters in and around Morristown, assuring that a wealthy upper class remained in the area. The struggle between the haves and have-nots continued, as did all of the inherent problems associated with that struggle.

Public transportation continued to evolve, and trolley and bus systems were created. The final connection to New York City was made in 1996, when direct train service was introduced, allowing residents to enter a train in Morristown and exit in New York's Penn Station. In 1999, Morristown was named an official "transit village." This designation paved the way for mixed commercial and residential development around the train station.

Morristown's story is not yet finished. Recent immigrant groups, many from Central and South America, have put their stamp on the community. The environmental movement has joined the historic preservation movement; green building construction and other initiatives are under way. Today's downtown looks vastly different than the downtown of just 10 years ago. What Morristown may look like in another 100 years is anyone's guess. Whatever the community's landscape may be in the future, the landscape of the past is found in the postcards on the following pages.

One

GEORGE WASHINGTON SLEPT HERE

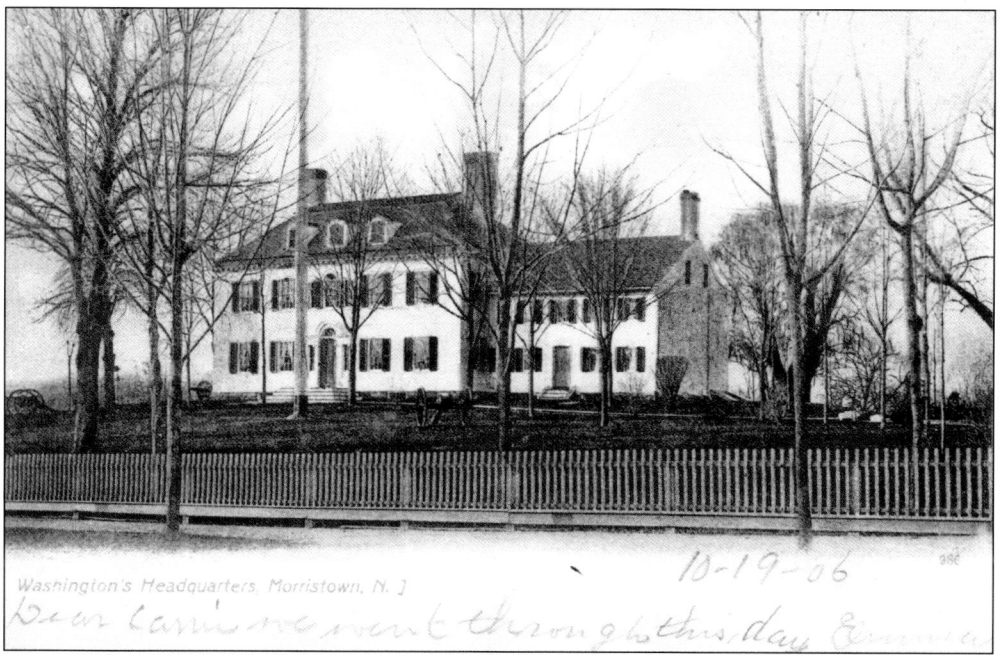

The Ford Mansion, also known as Washington's Headquarters, was built between 1772 and 1774. It served as the residence and offices of General Washington and his closest advisors during the winter of 1779–1780. It was purchased in 1873 by the Washington Association and became a museum. The property was later acquired by the National Park Service and became part of the first National Historical Park in 1933.

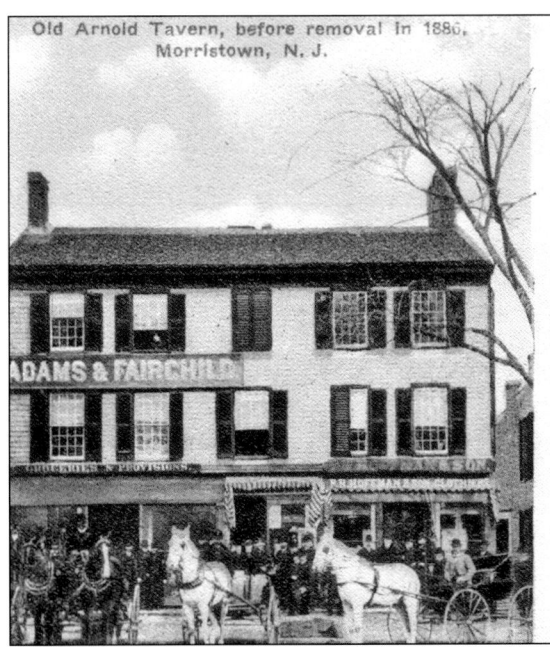

Old Arnold Tavern, before removal in 1886, Morristown, N. J.

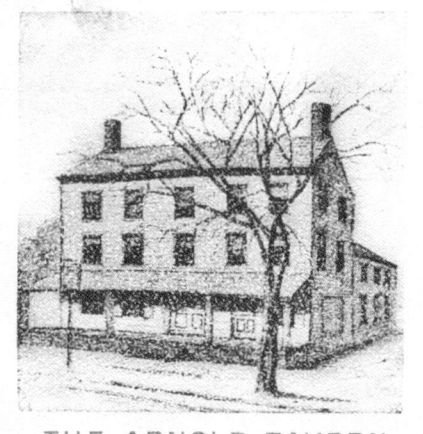

THE ARNOLD TAVERN

Kept by Col. Jacob Arnold, of famous Light Horse Troop., War for Independence, —Washington's Headquarters, winter of 1776-1777. Tavern since removed and converted into the All Souls' Hospital.

From "Historic Morristown"

The Arnold Tavern was the location of Washington's first headquarters in Morristown. Washington stayed here during the winter of 1777. It was later used as housing for quartermaster general Nathanael Greene. In the 1800s, it was converted into apartments and street-level storefronts. It was moved in 1886 to Mount Kemble Avenue and used for All Soul's Hospital. The building was partially destroyed by fire and torn down in 1918. (MHHM.)

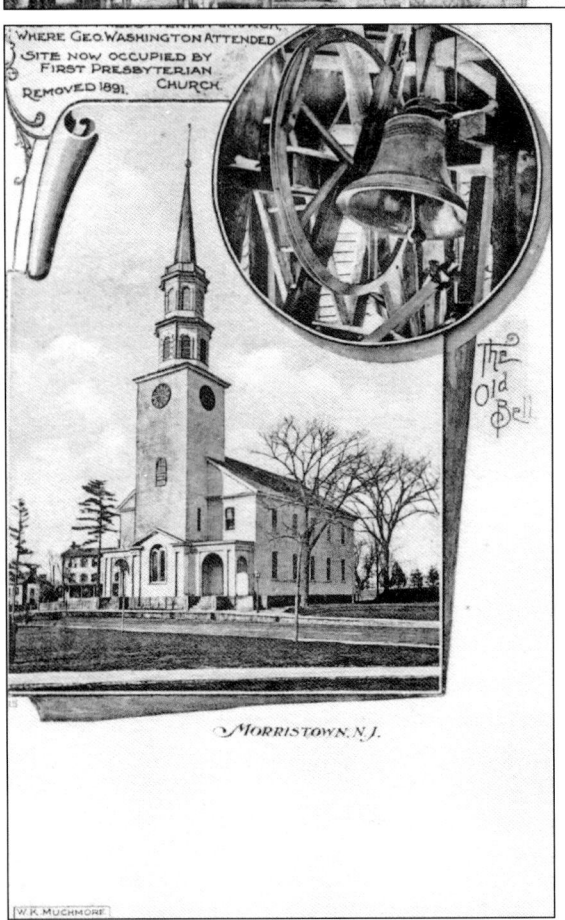

The Presbyterian Church in Morristown is the town's oldest organization. Built for a newly established congregation in 1738, this building was enlarged twice and torn down to make way for a new church in 1795. In 1777, during the Revolutionary War, it was used to house victims of the smallpox epidemic. Although he was not Presbyterian, church legend states that Washington received communion in the churchyard. (MHHM.)

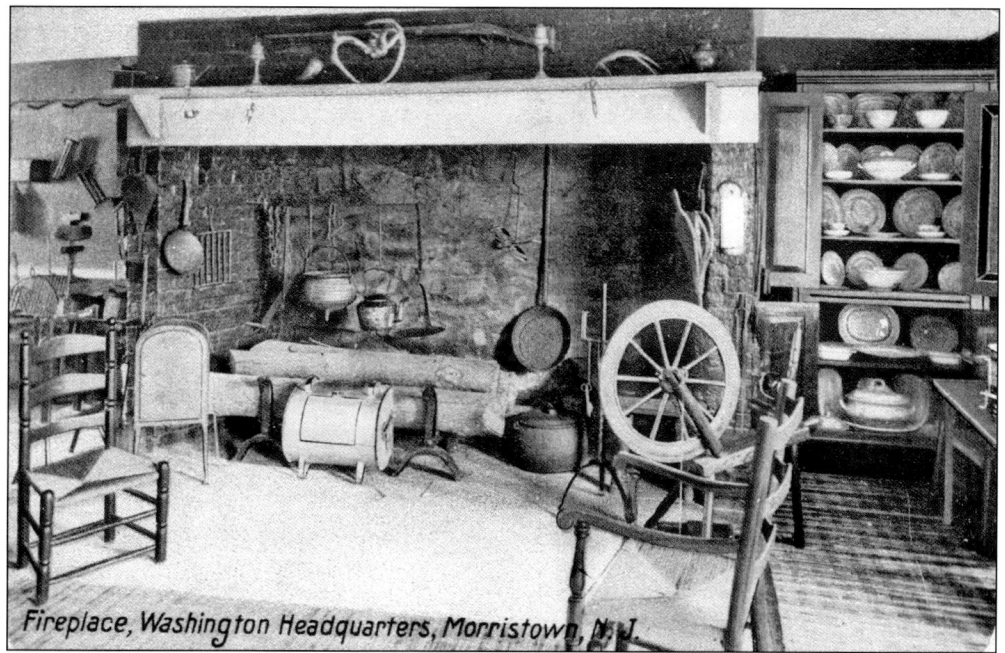

Fireplace, Washington Headquarters, Morristown, N. J.

When Washington took up residence in 1779, the Ford Mansion was home to the widow of Col. Jacob Ford Jr., Theodosia Ford, as well as her four children and their servants. The Ford family was allowed the private use of only two rooms during Washington's residency. Washington and his entourage included nearly 25 people, including his aides, servants, and wife, Martha. Washington added a new kitchen, but the shared space would have been tremendously crowded. The parlor scene below is not representative of what it would have looked like in Washington's time, but served as a display area of Washington imagery during the tenure of the Washington Association. Huts on the grounds near the home were used by Washington's Life Guard.

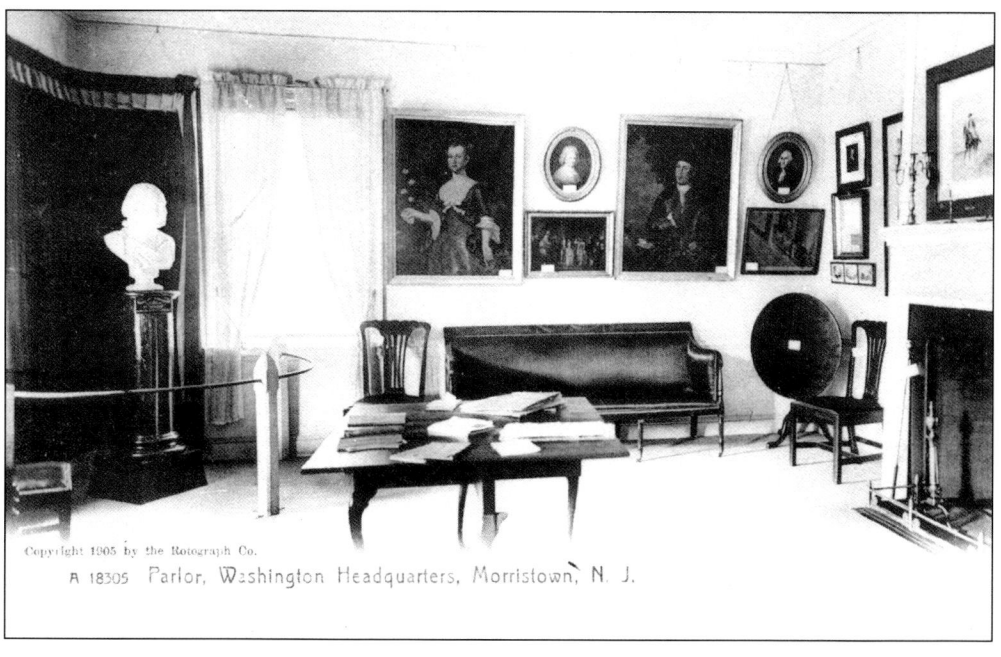

Parlor, Washington Headquarters, Morristown, N. J.

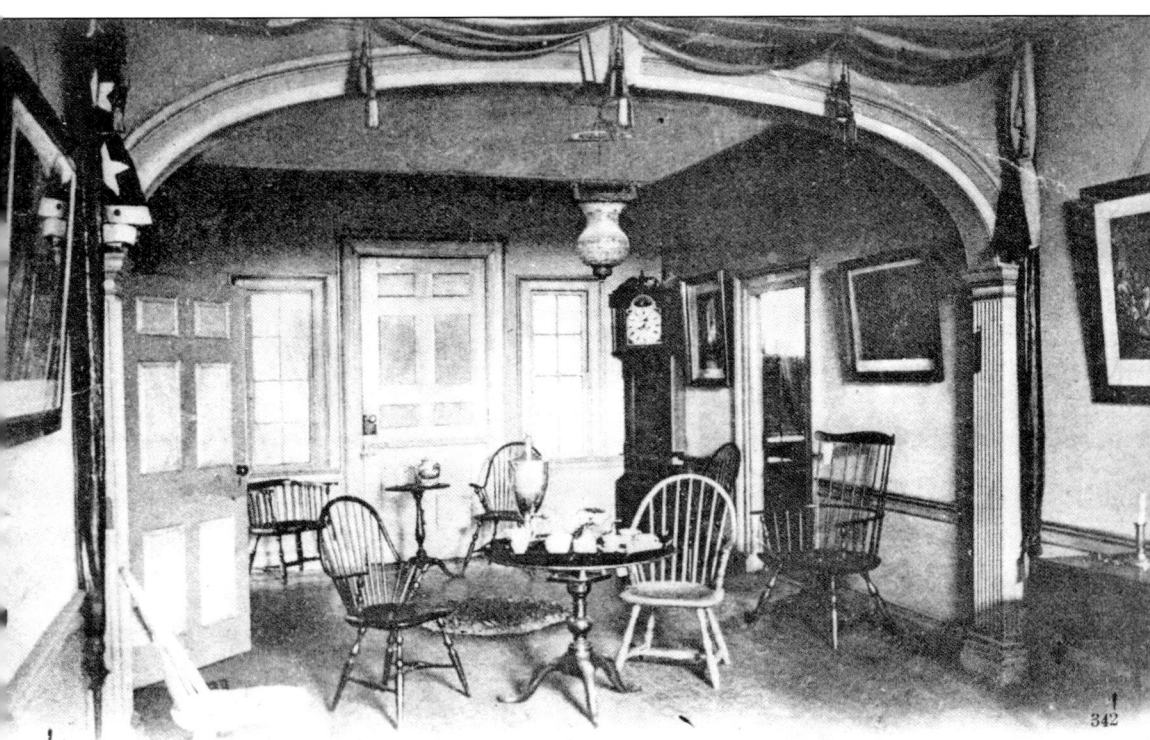

Interior of Washington's Headquarters, Morristown, N. J.

The wide center hallway of the Ford Mansion would have been used for a variety of activities during Washington's stay. There are several accounts of dances and other social events taking place while Washington and his army were in residence in Morristown. One lesser-known historical fact is that, on St. Patrick's Day in 1780, Washington declared a day off in recognition of the contributions of Irish soldiers.

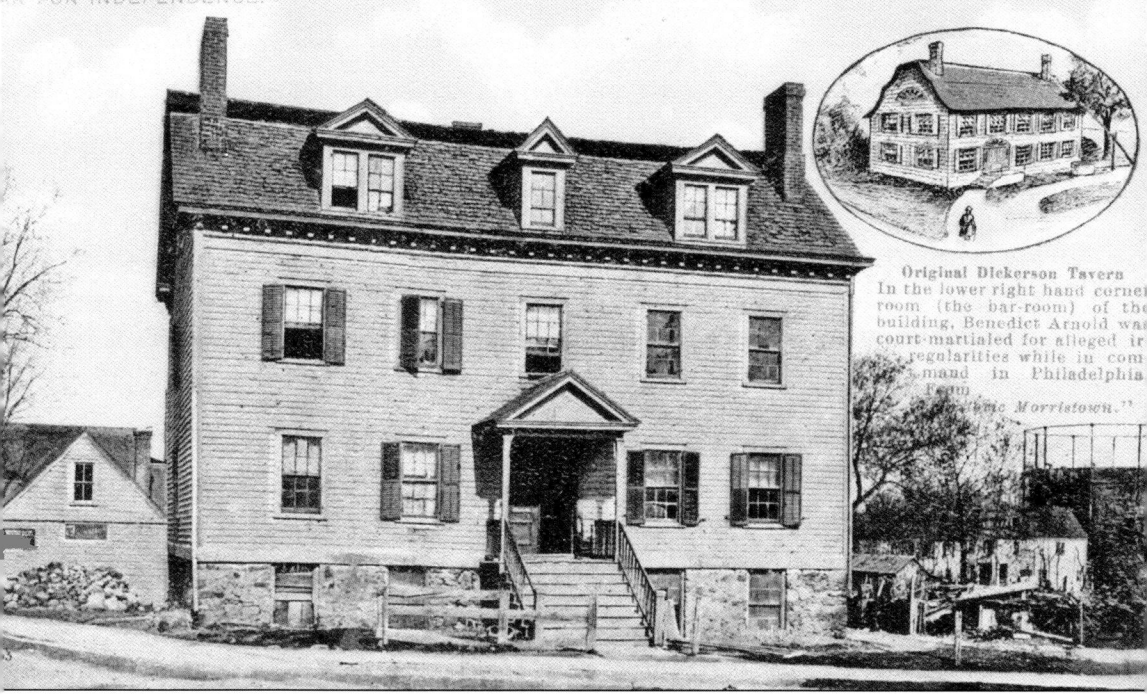

Dickerson's Tavern (also known as Norris' Tavern) was located at the corner of Spring and Water Streets. It was the site of the first court-martial of Benedict Arnold, who faced a variety of charges for his actions in Philadelphia in 1779. He was found guilty of two charges and was reprimanded by Washington. He went on to become the most notorious traitor of the Revolution. (MHHM.)

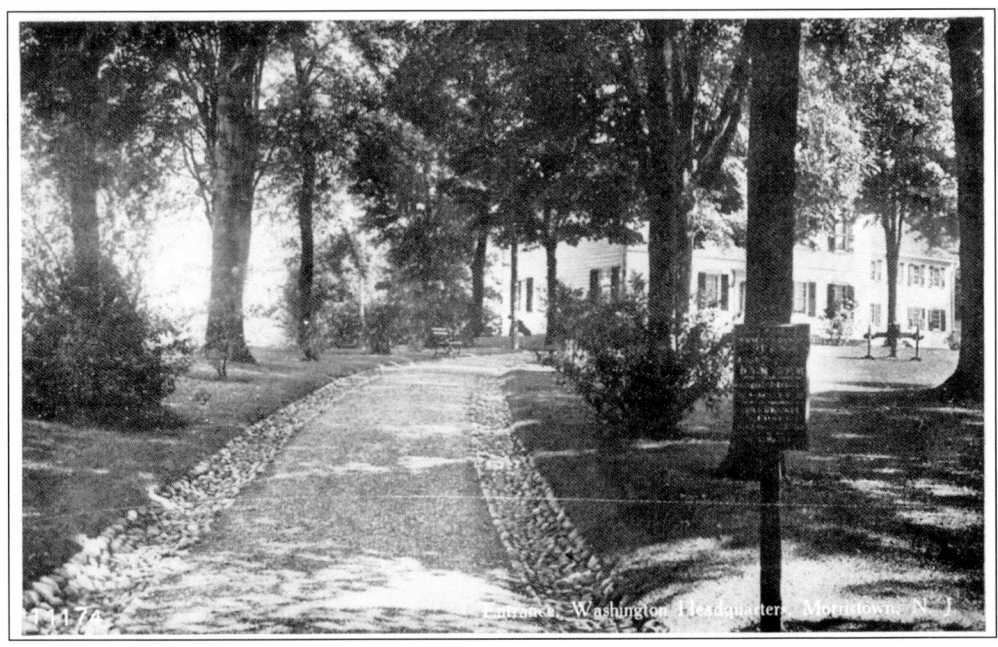

These two images date from the period that Washington's Headquarters was operated by the Washington Association. The group was formed in 1873, when four local men banded together to purchase the home from the descendants of the original builder, Col. Jacob Ford Jr. By forming the Washington Association, they founded one of the first historic preservation groups in the country. Although they deeded the property to the National Park Service, the Washington Association is still in existence, providing support for ongoing preservation. The driveway in the front of the mansion, seen above, and the lush gardens, pictured below, in the back have long since been replaced.

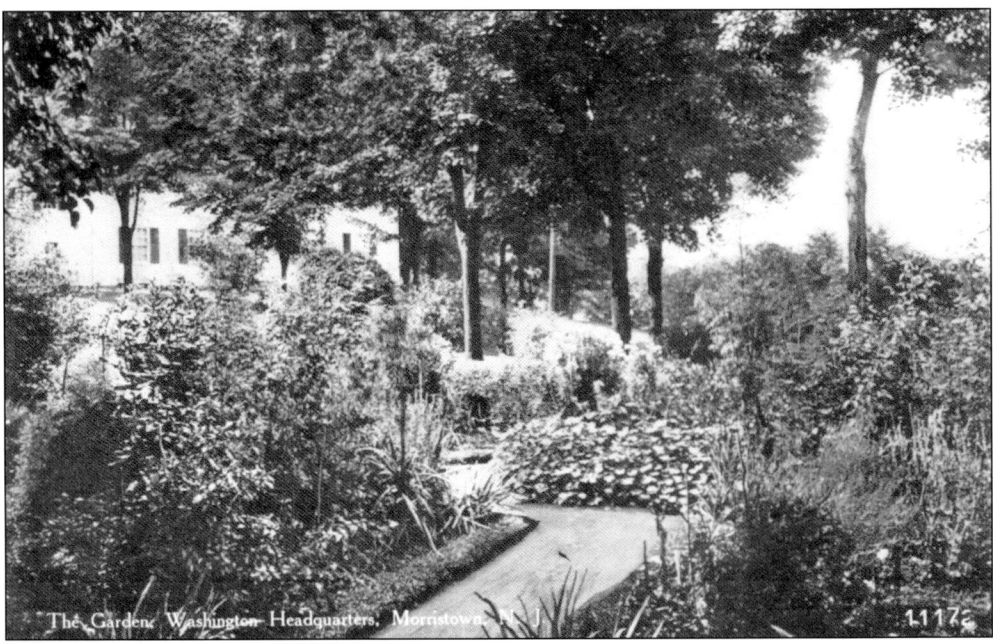

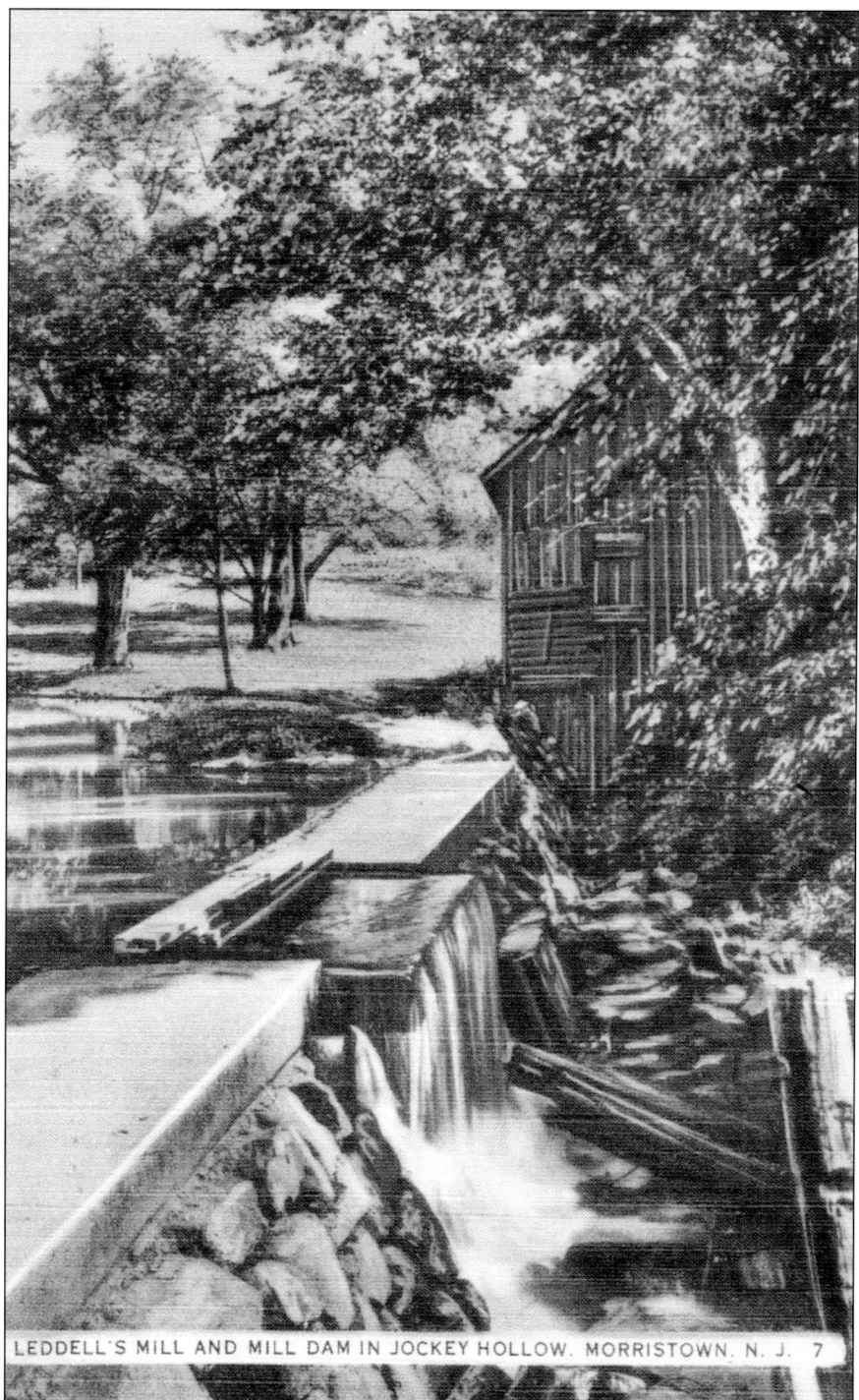

LEDDELL'S MILL AND MILL DAM IN JOCKEY HOLLOW. MORRISTOWN, N. J. 7

Dr. William Leddell was a Morristown physician during the time of the Revolutionary War. He was related to Tempe Wick, who is part of an enduring local legend of a young woman protecting her horse from deserting soldiers. Leddell's property, situated near the encampment at Jockey Hollow, had a mill used to grind grain. The mill was in operation for more than 100 years.

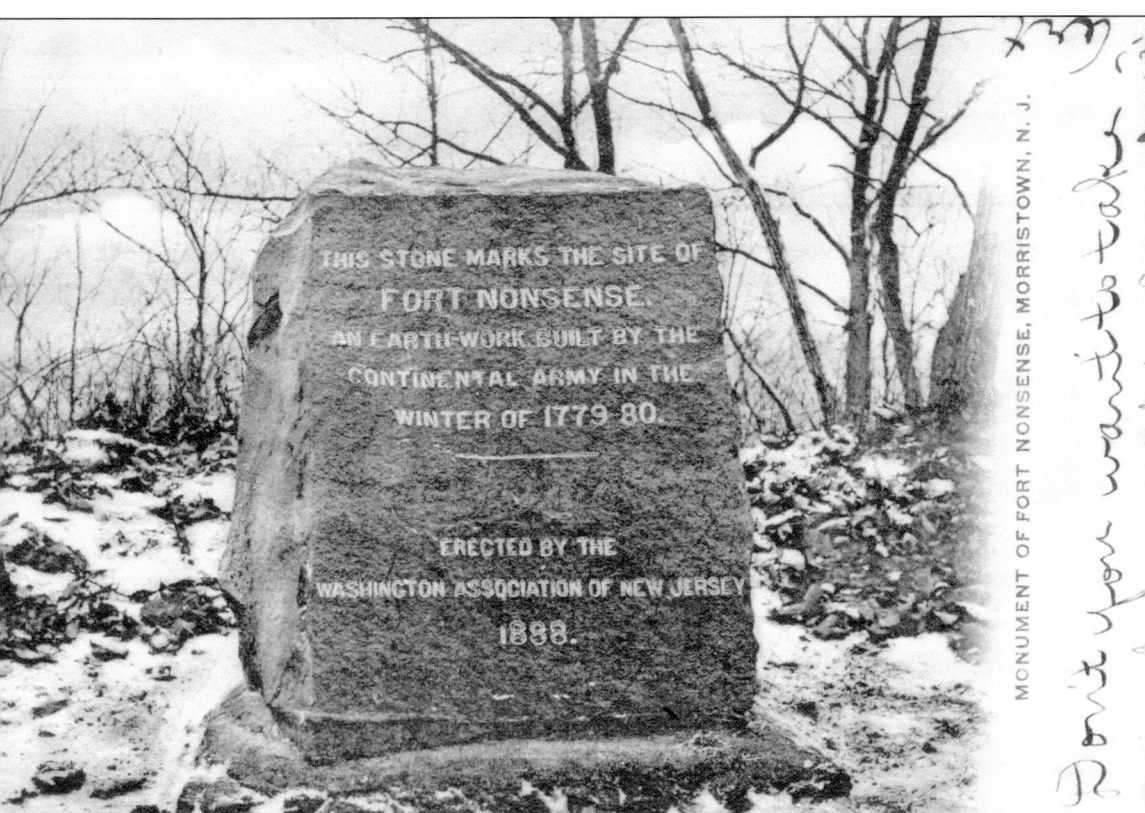

During the winter of 1777, Washington instructed his troops to build a fortification on the hill overlooking Morristown. Local lore had it that the site was named Fort Nonsense because it was built simply in an effort to keep the men busy during the winter, although historians dismiss this story. Today, the site is part of Morristown National Historical Park. Note that the dates on the marker are incorrect.

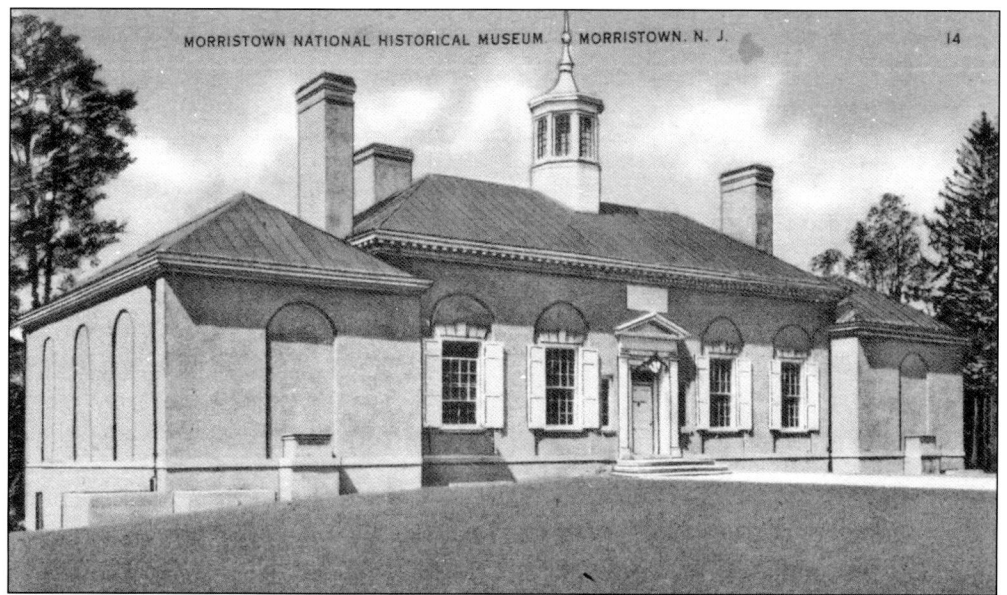

When the Washington Association turned the Ford Mansion over to the National Park Service, it requested that a fireproof museum be constructed to house the artifacts that the association had acquired. Designed by the distinguished architectural firm of John Russell Pope, the museum opened on Washington's birthday on February 22, 1938. New wings were added in 1957 and 2007. The building includes galleries, a library, an auditorium, a gift shop, and admissions.

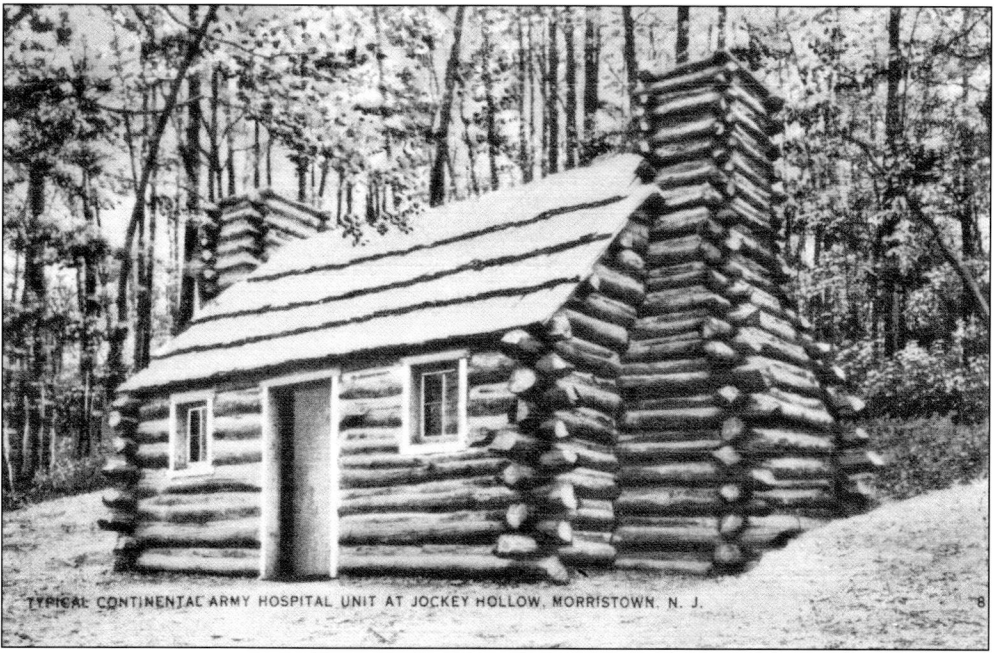

Now known for its forested landscape, during the Revolution, the Jockey Hollow area was denuded of its trees for the construction of the approximately 1,000 huts that housed the Army. During the Depression, reconstructions of the huts were built by the Civilian Conservation Corps. Jockey Hollow was the site of the Revolution's worst mutiny of enlisted soldiers on January 1, 1781.

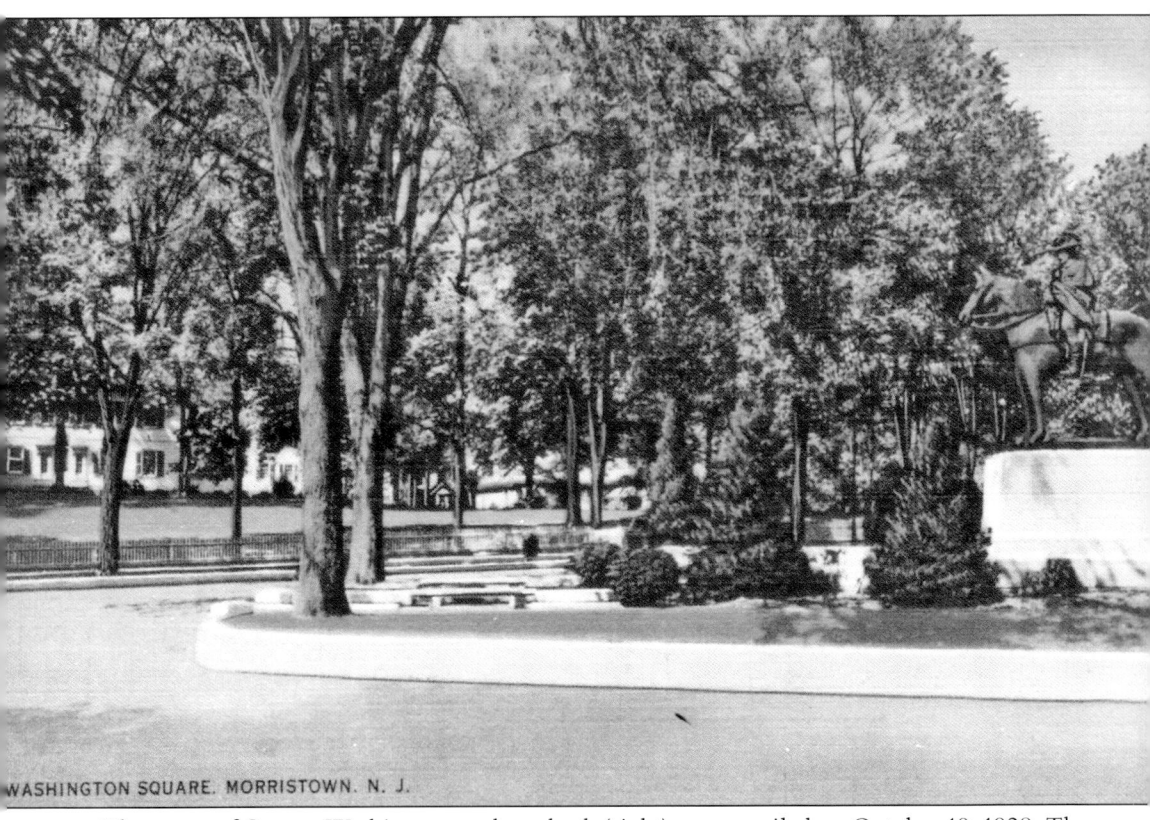

The statue of George Washington on horseback (right) was unveiled on October 19, 1928. The date commemorated the British surrender at Yorktown. The statue was sculpted by Frederick George Richard Roth and donated by Ellen Mabel Clark, and the property for the small park was donated by Dr. Henry N. Dodge. The park was recently restored.

Two

Historic Sites

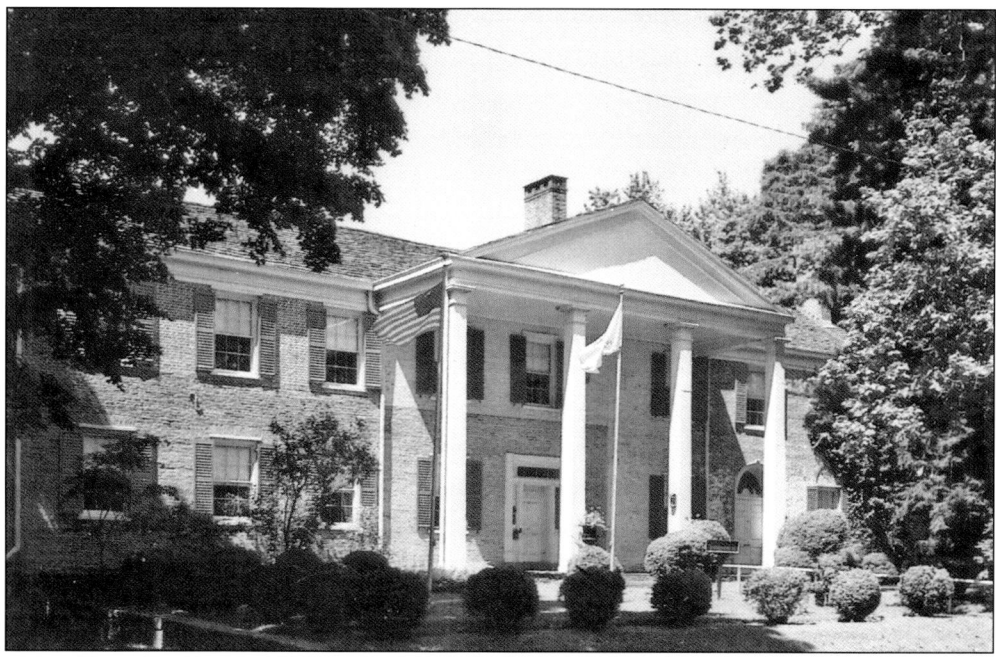

Macculloch Hall was built in 1810 by Scottish immigrant George P. Macculloch, a prominent local citizen and one of the early architects of the Morris Canal. The mansion was acquired in 1949 by W. Parsons Todd, who used it to house his collection of antiques. Today, it is operated as the Macculloch Hall Historical Museum and features period rooms, changing exhibits, and historic gardens.

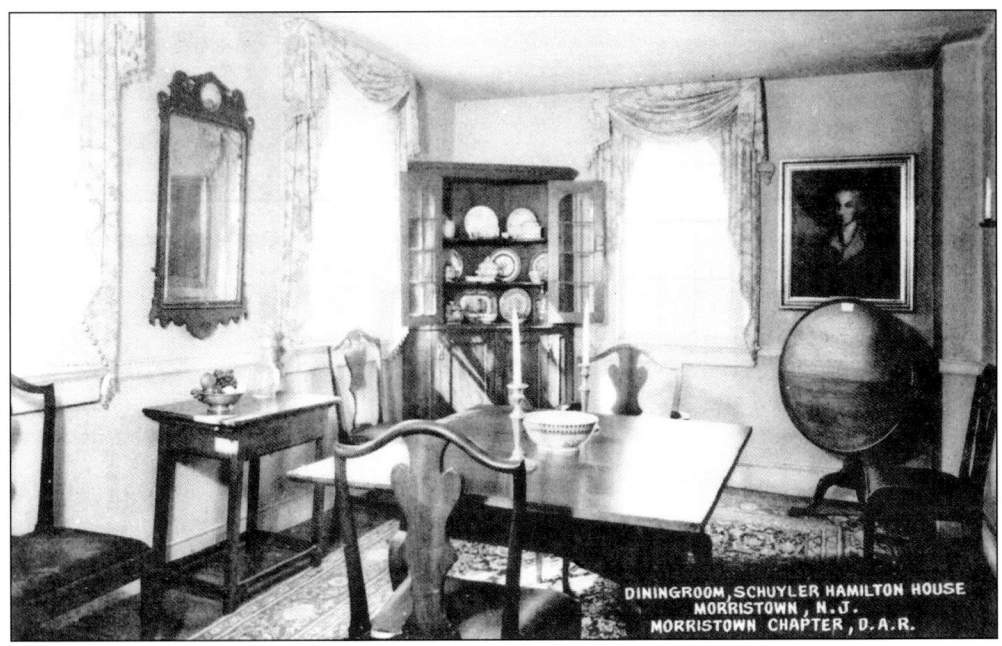

DININGROOM, SCHUYLER HAMILTON HOUSE MORRISTOWN, N.J. MORRISTOWN CHAPTER, D.A.R.

During the winter of 1779–1780, while Gen. George Washington occupied the home of the Ford family, additional high-ranking members of the Continental Army stayed at other local homes. Dr. John Cochran, chief physician and surgeon, stayed with local surgeon and fellow patriot Dr. Jabez Campfield. Dr. Cochran's wife, as well as his niece Betsy Schuyler, also stayed at the home. Betsy Schuyler was courted by the dashing young Alexander Hamilton, Washington's aide-de-camp. The couple later married, and Hamilton became the first secretary of the treasury. He is best remembered for his fatal duel with Vice Pres. Aaron Burr. The home was saved from demolition in 1923 by the Morristown chapter of the Daughters of the American Revolution. Today, it serves as their headquarters and museum.

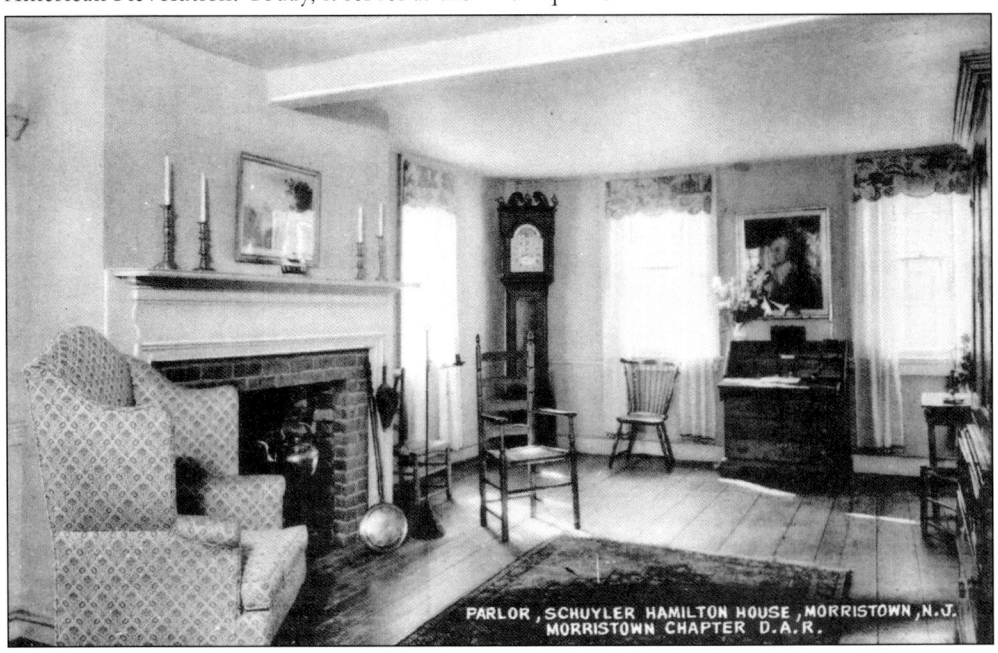

PARLOR, SCHUYLER HAMILTON HOUSE, MORRISTOWN, N.J. MORRISTOWN CHAPTER D.A.R.

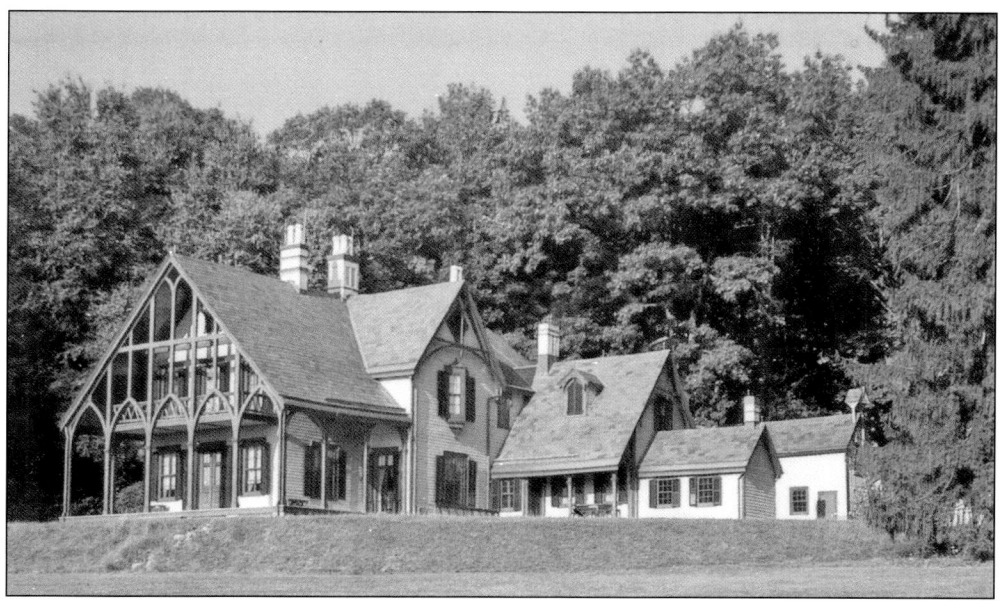

Joseph Warren Revere, grandson of Paul Revere, built the Willows in 1853. After his Civil War service, Revere rented the out the home, and it was briefly rented by author Bret Harte. It was eventually purchased by Charles Foster, a widower who renamed it Fosterfields and lived there with his daughter Caroline. Today, the Gothic Revival–style home is open for tours as part of Fosterfields Living Historical Farm.

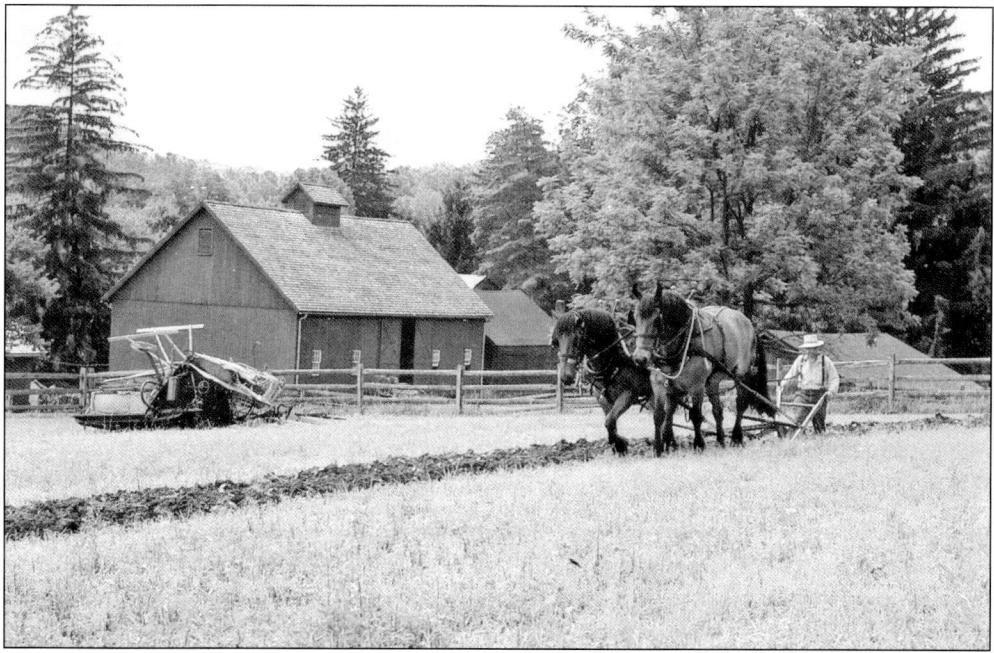

Caroline Foster lived at Fosterfields from 1877 to 1979. Part of Morristown's high society in her youth, she later became a local historian and farmer. Witnessing Morristown's development from a small town edged with farms to an urban center, she wanted to ensure that future generations would understand the farm life that she loved. She bequeathed her property to the Morris County Park Commission as a living history museum.

21

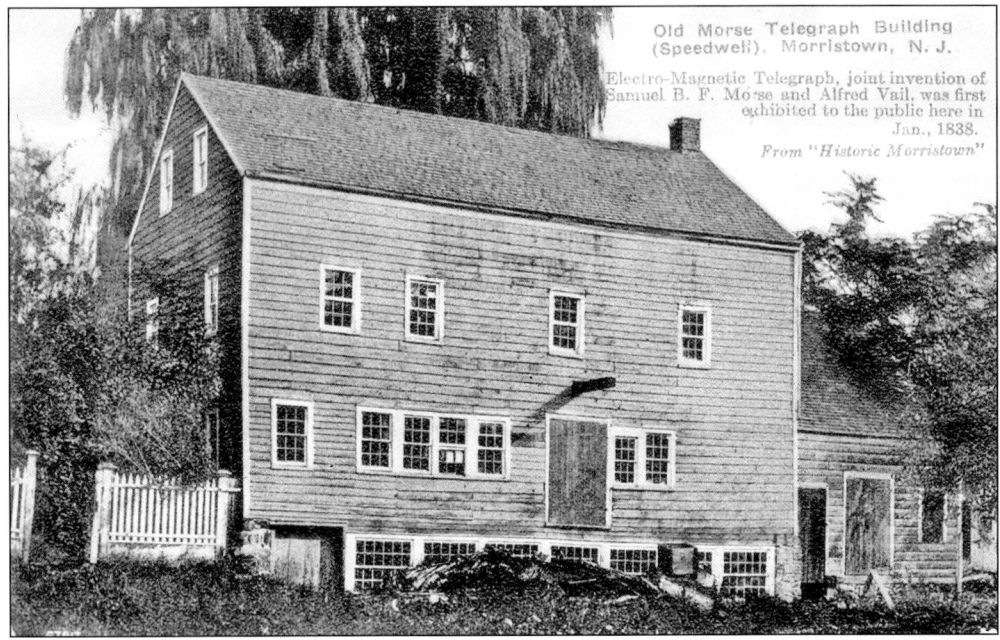

On the top floor of the Factory Building, shown here, Stephen Vail's son Alfred demonstrated the telegraph. Alfred Vail was contracted to construct a working model of a telegraph on behalf of Samuel F.B. Morse, whom he met while studying at New York University. The first public demonstration of the telegraph was conducted in Morristown in January 1838, followed by demonstrations in New York, Philadelphia, and Washington, DC. Alfred returned to Speedwell to make improvements on the device, while Morse took it to England, France, and Russia. Eventually, in 1843, Congress appropriated $30,000 to construct the first telegraph line. Alfred was appointed assistant superintendent of the project. He retired in 1849; despite his major contributions to the development of the telegraph, he never received the same level of recognition and wealth as Morse did. (Above, MCPC.)

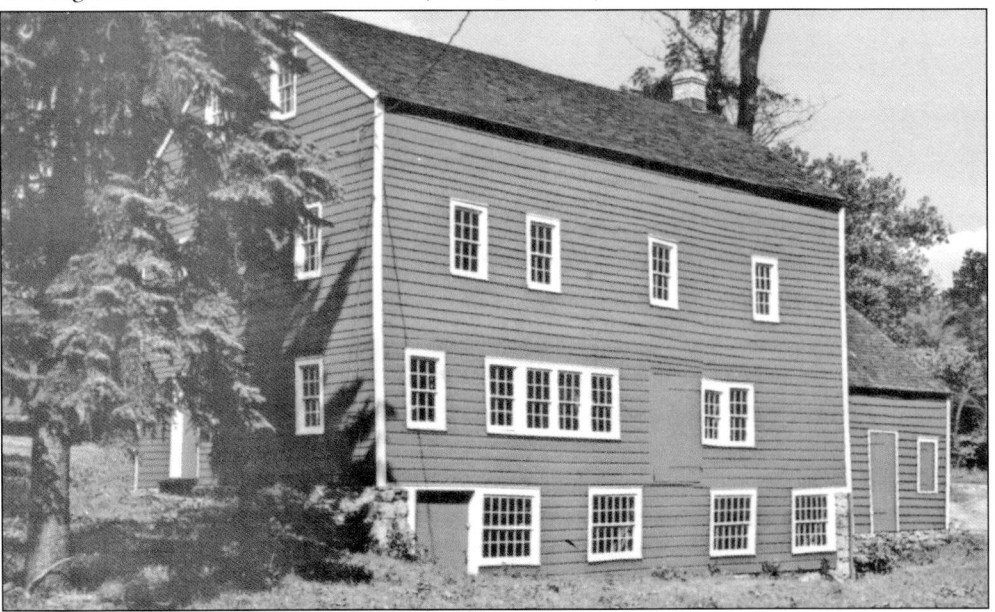

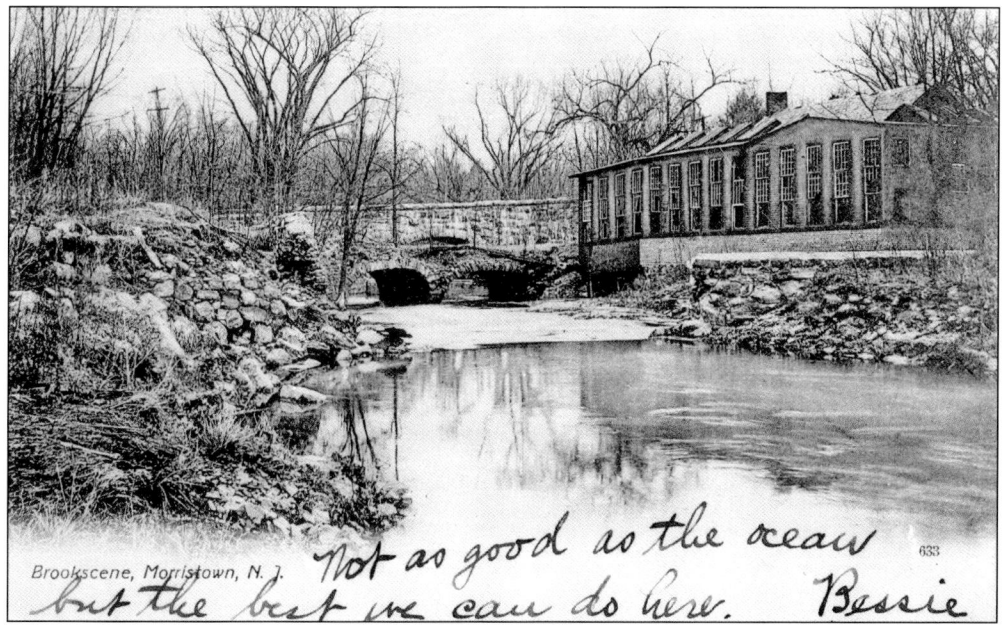

Brookscene, Morristown, N. J. *Not as good as the ocean but the best we can do here. Bessie*

These two images show the remains of Stephen Vail's industrial empire. The Speedwell Iron Works, later operated by Vail's son George, was part of the larger Morris County iron industry that included a network of mines, forges, and furnaces. Stephen Vail ensured that his company was involved in numerous industries, including those working to develop parts and machinery for the railroad industry and the engine of the SS *Savannah*. The SS *Savannah* was the first ship to use steam power on a transatlantic voyage. At its height, Speedwell employed 45 men as skilled and unskilled laborers. The building was mislabeled, as the telegraph factory was part of the Speedwell Iron Works, located where Speedwell Lake Park is today. Stephen's home, the Factory Building, waterwheel, and other notable buildings are now operated as a historic site by the Morris County Park Commission. (Both, MCPC.)

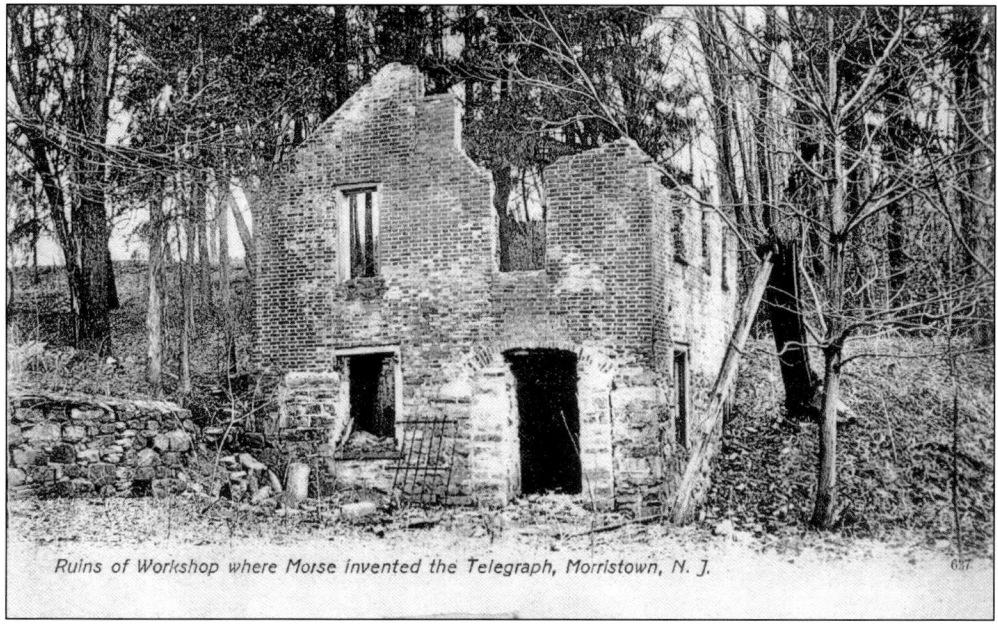

Ruins of Workshop where Morse invented the Telegraph, Morristown, N. J.

Acorn Hall was built in 1853 by Dr. John Schermerhorn. Acquired by Augustus Crane in 1857, the home was enlarged, and the Italianate tower was added to the front. Crane and then his descendants lived in the home until 1971, when Mary Crane Hone gave the building and several surrounding acres to the Morris County Historical Society. Hone, originally a stage actress, became a political activist and proponent of historic preservation. Today, Acorn Hall is open as a museum featuring both period rooms and changing exhibits. It has been nationally recognized as an exceptional example of Victorian Italianate architecture. It retains much of its 19th-century interior, including the parlor, which features original wall coverings, carpeting, and furniture. (Above, Pam Hasegawa.)

Three

THE GILDED AGE

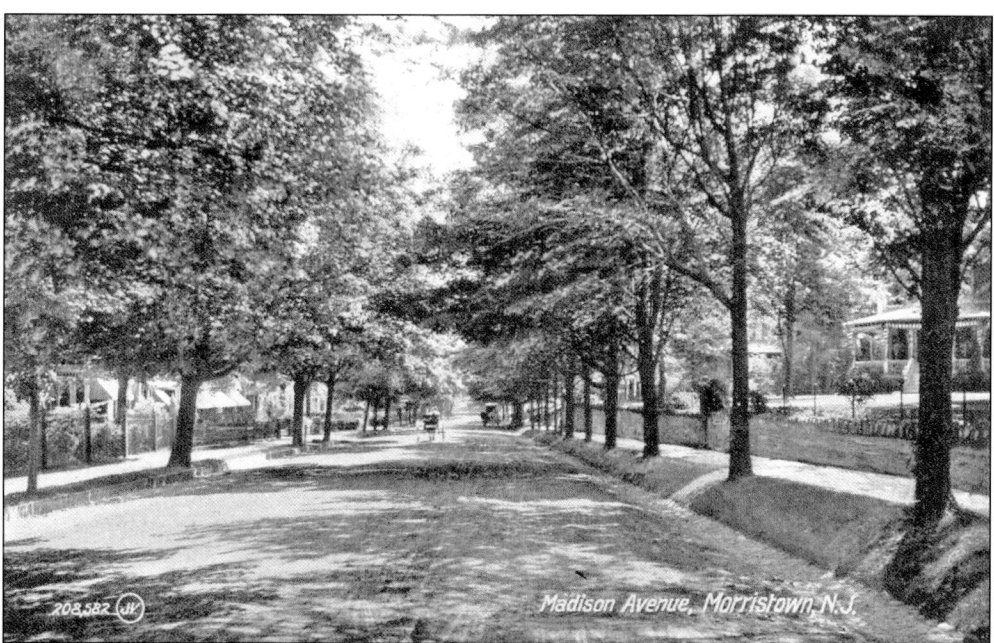

Madison Avenue has been called "Morristown's Millionaire Mile" and was known for "large residences of various types and designs, with broad lawns and mammoth trees." While there were tremendous estates throughout parts of Morristown and Morris County, it is Madison Avenue between Morristown and Madison that is recalled by local residents as the focal point of the Gilded Age.

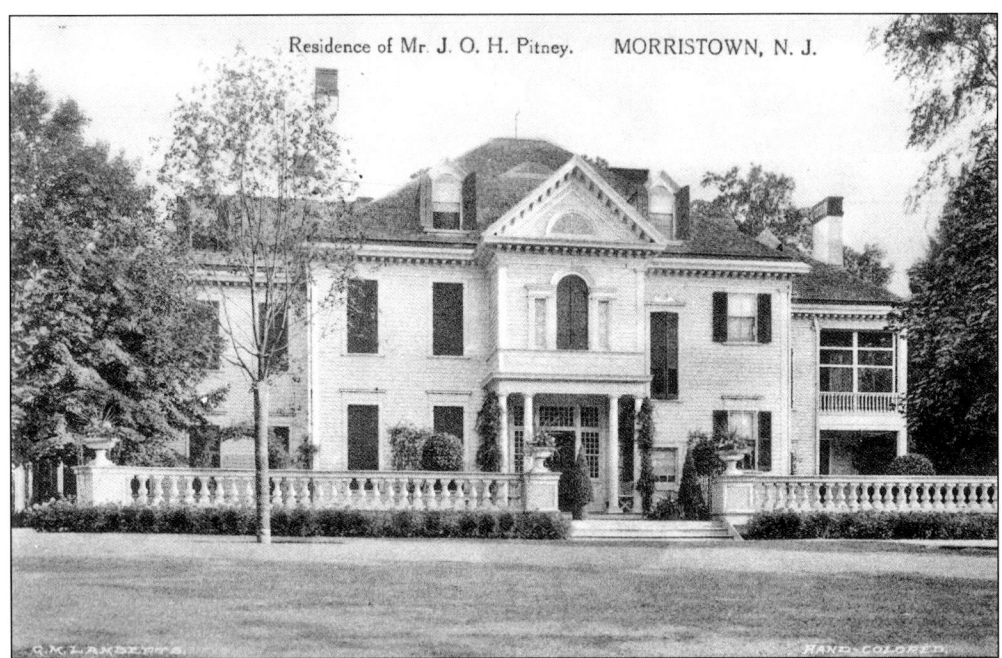

The John Pitney residence was located at 127 Madison Avenue and was part of the former estate of New Jersey governor Theodore F. Randolph. It is no longer standing. Pitney was a prominent lawyer, and his wife was a member of the Newark Ballantine family, who operated the P. Ballantine and Sons Brewing Company. The Ballantine mansion in Newark is now a focal point of the Newark Museum. (MCPC.)

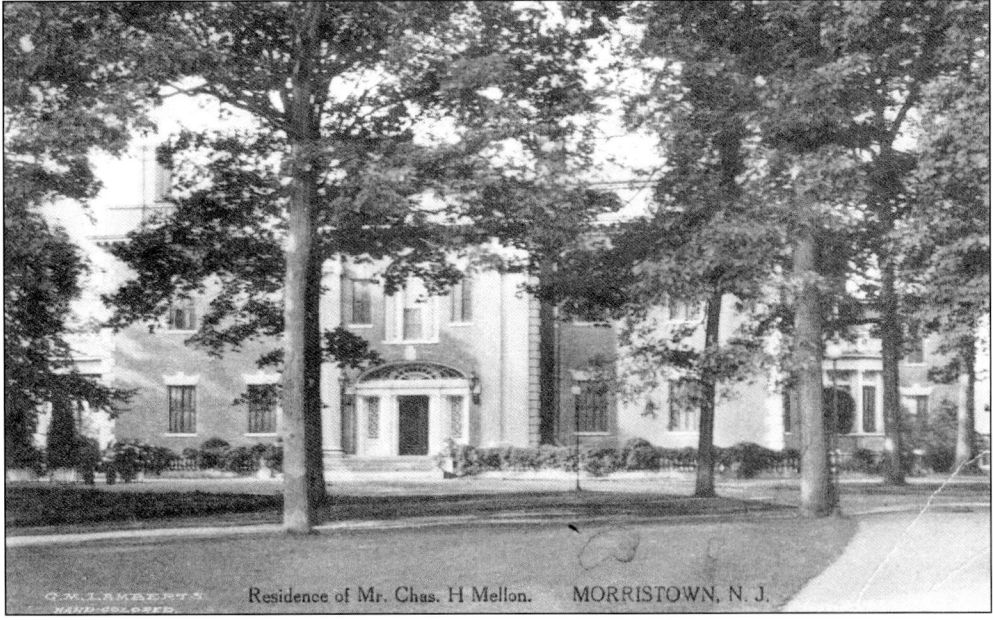

Charles Mellon built this brick and marble home in 1901 along Madison Avenue, also on the site of the former residence of Governor Randolph. Charles was a cousin of Andrew Mellon and a successful investment broker. The building was torn down after a devastating fire in 1934. It is now the site of Morristown Medical Center.

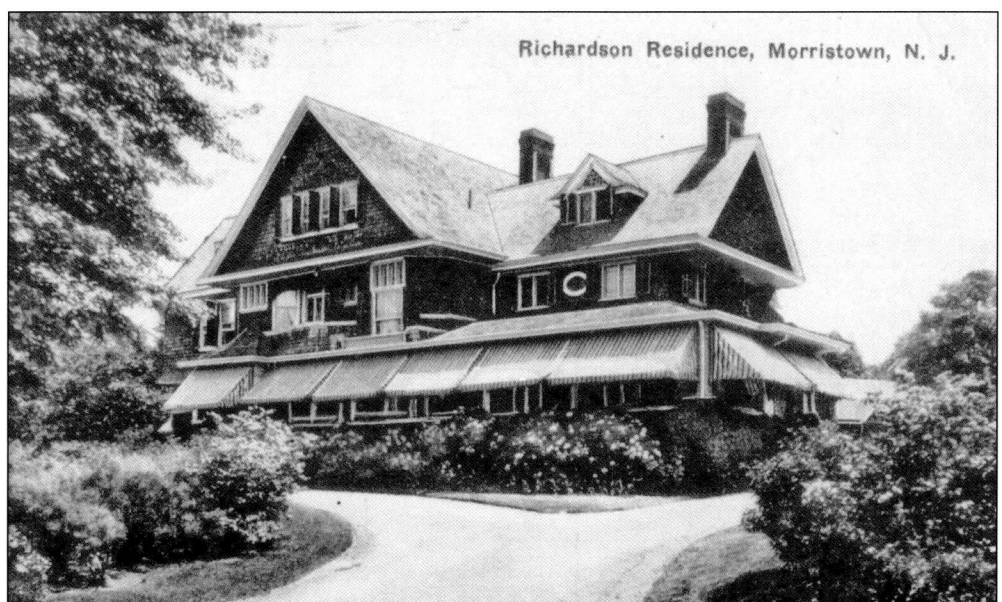

Frederick B. Richardson was president of Richardson & Boynton Company, of Dover. The company manufactured a variety of cast-iron stoves. Several of the company's Perfect model can still be found in historic houses in Morristown. Richardson was active in the Morris County Golf Club and the Whippany River Club. The Madison Avenue home is no longer standing. (Lewis Feldman.)

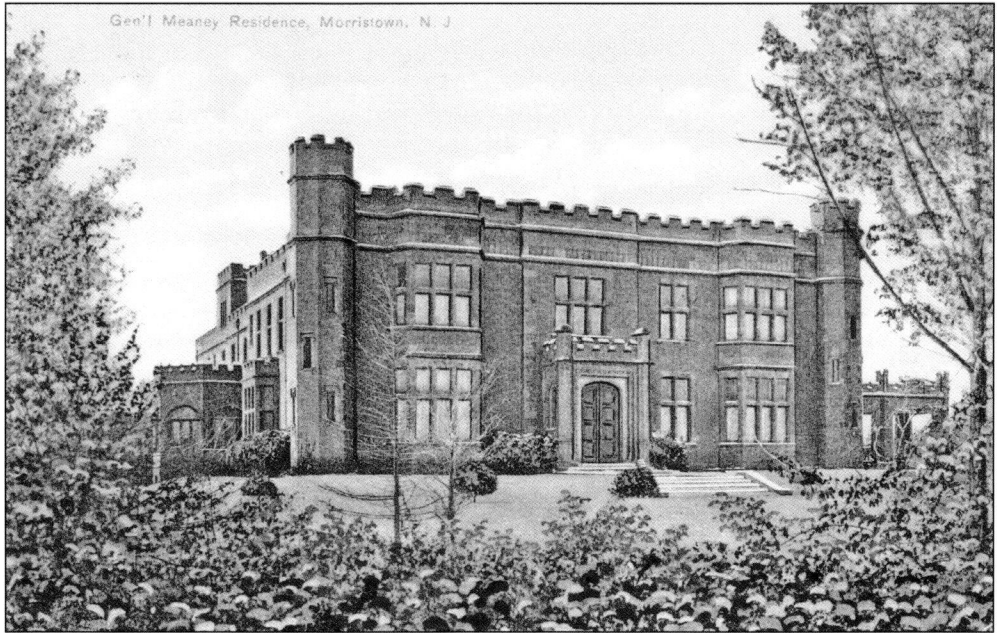

Alnick Hall was the home of Edward and Rosalie Meany. Inspired by Alnick, a baronial manor in England, the home had many novel innovations for the time. It featured central heating with room controls and a built-in vacuum system. Never accepted socially by the other elite of Morristown, the couple nonetheless entertained extensively and was known for their musical events. The structure is now an office building. (Lewis Feldman.)

HYDE RESIDENCE, MORRISTOWN, N. J.

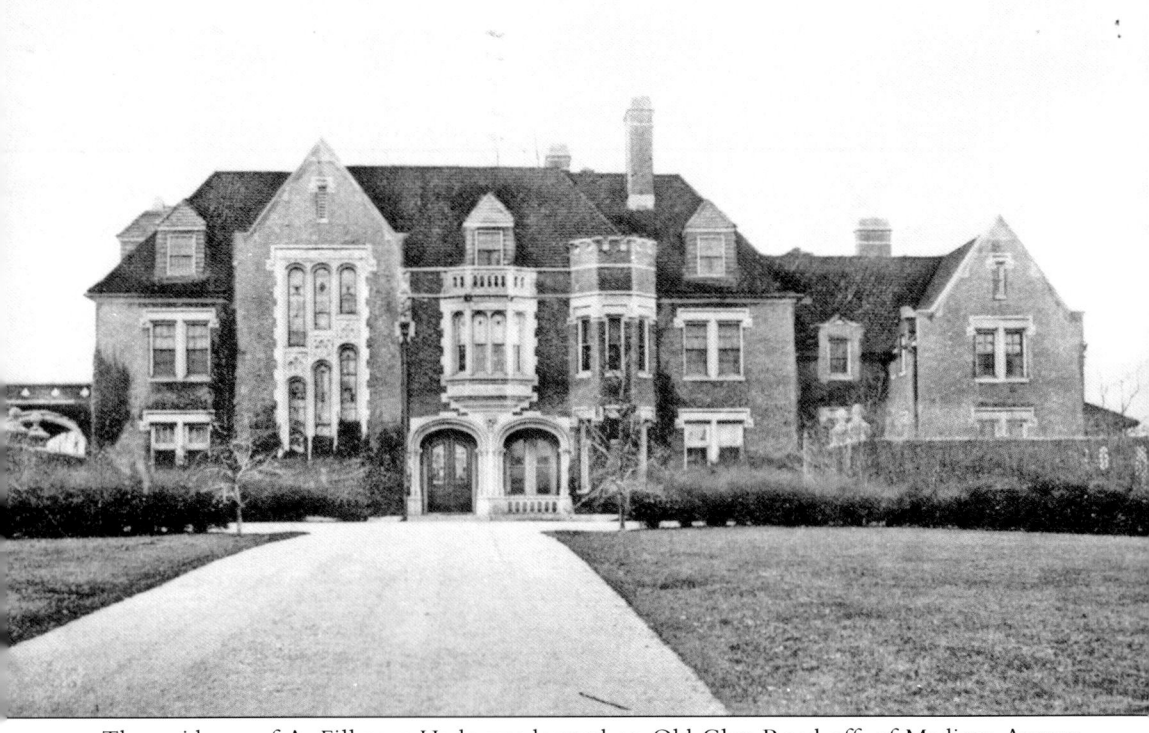

The residence of A. Fillmore Hyde was located on Old Glen Road off, of Madison Avenue, in the Convent Station section of Morristown. Hyde was a real estate tycoon whose wealth was estimated at a staggering $14 million, over $320 million today. The house is alternatively listed as Seldomere or Seldomhere. The mansion was razed for a housing development. (Lewis Feldman.)

o. Marshall Allen's Residence, Morristown, N. J.

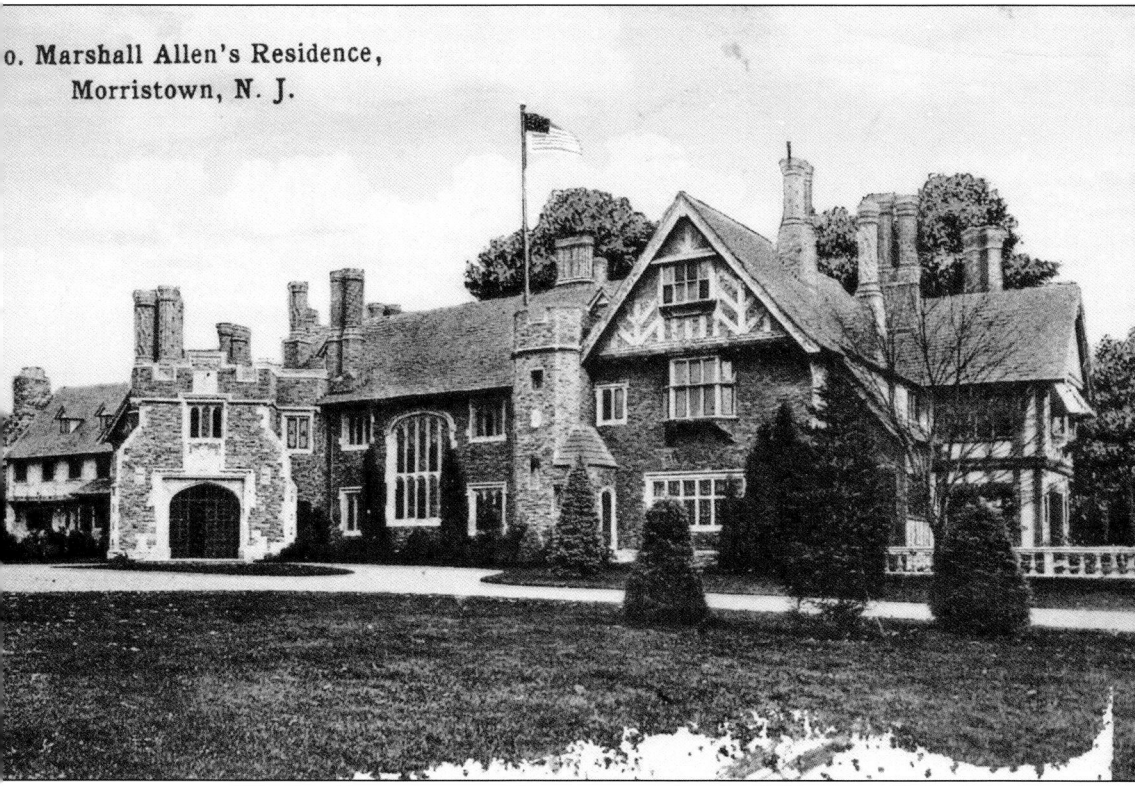

George Marshall Allen, who headed his own publishing company, began building his home just off of Madison Avenue in 1913. Named Glynallyn, the Tudor-style architecture of the home was based on Compton Wynyates in England. Construction was interrupted by World War I, and it was not finished until 1917. The mansion is still standing and was featured as the Mansion in May designer showcase home in 2012.

Although South Street is most identified with the urban downtown area today, in the 19th century, St. Peter's Church roughly marked the beginning of the residential district. Like Madison Avenue, it was a wide, tree-lined avenue dotted with elaborate mansions with large landscaped properties. Few of these residences are still standing.

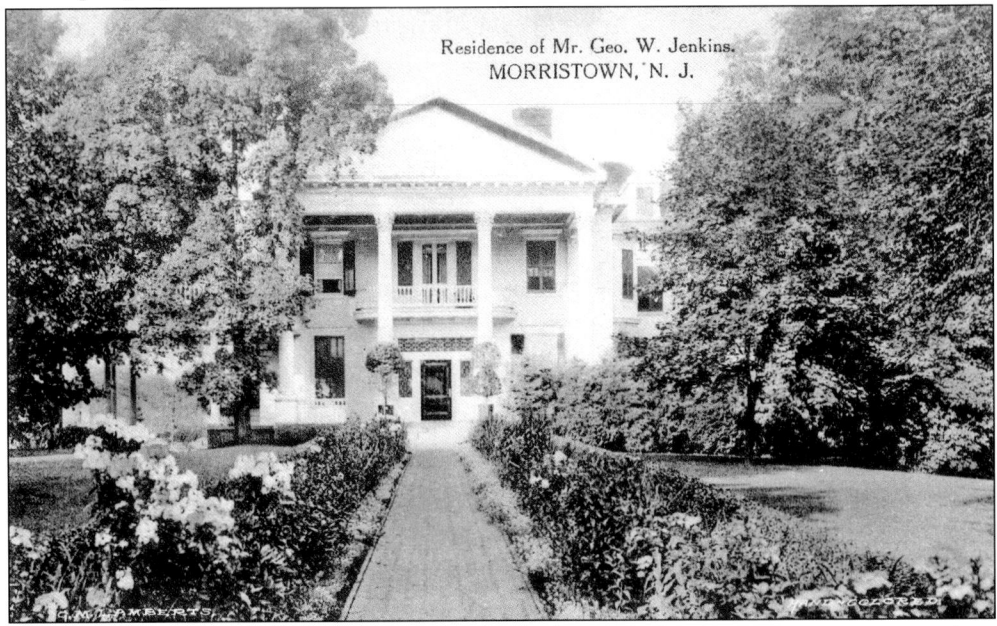

The Jenkins home at 238 South Street was a striking Colonial Revival mansion. George Jenkins was a banker, and his wife was an heiress and philanthropist related to the Dodge family. The garage on the property had an elevator to enable cars to be moved to the second floor for storage. It was torn down in the 1970s and is now the site of an office building, Ten Madison Avenue. (MCPC.)

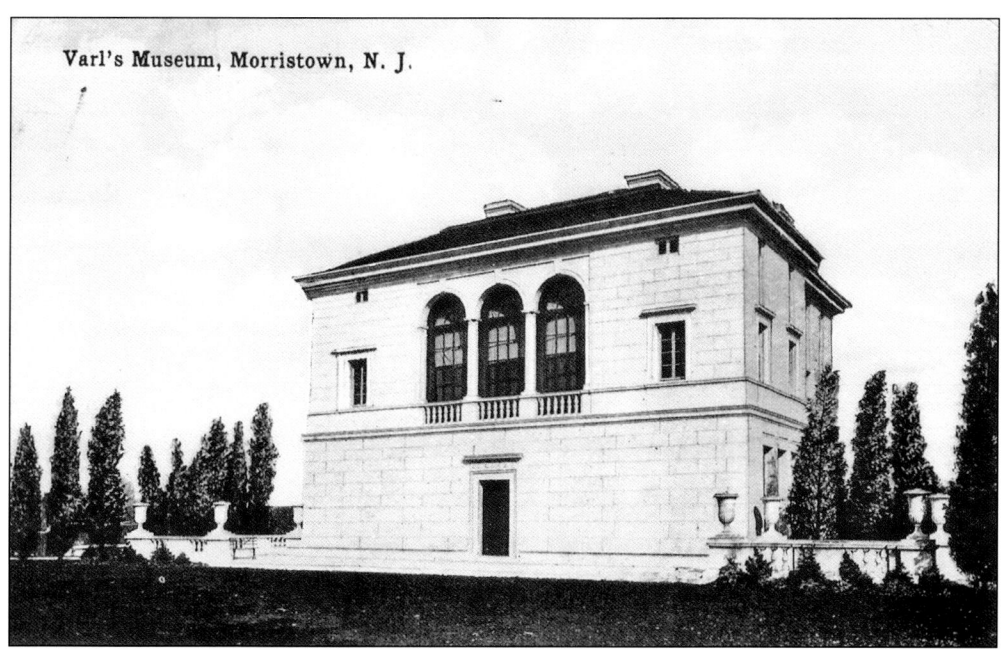

Varl's Museum, Morristown, N. J.

Theodore Vail came to Morristown as a young man, and at age 17, he worked as a telegraph operator. He went on to become the first president of AT&T in 1885. Vail built this granite and Italian marble building on South Street between 1916 and 1918 to serve as his home and a museum. The bronze doors on the front of the building have eight relief panels; seven depict the early history of Morristown. Vail was living in New York City while his mansion was being built and died before it was completed. The building was later acquired by the town and served for many years as the municipal building. In 2008, a large addition was built, and the Vail Mansion became the centerpiece of a luxury condominium development. (Above, MCL.)

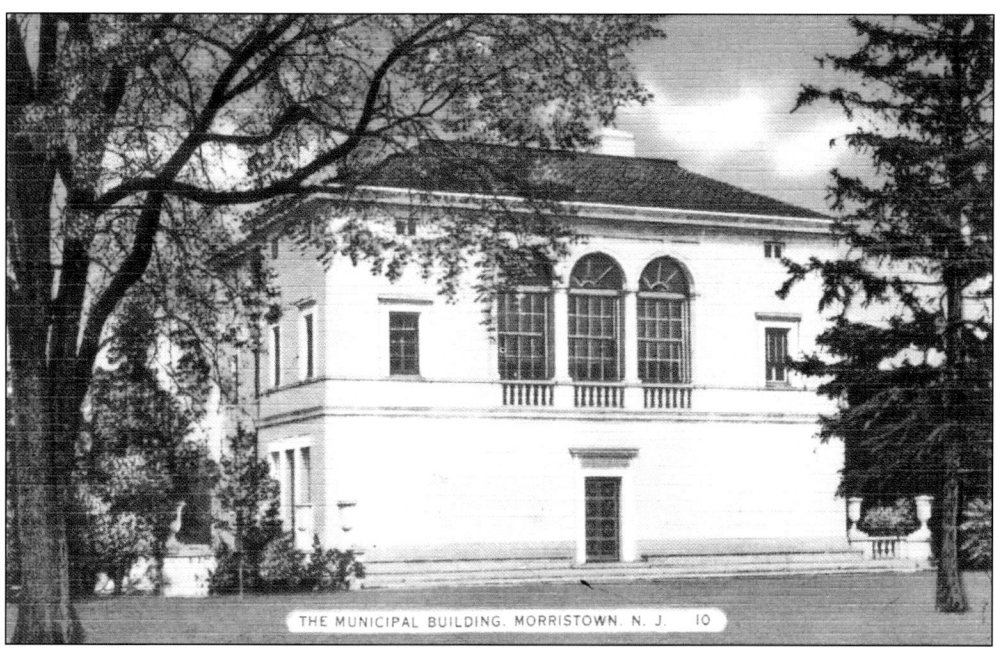

THE MUNICIPAL BUILDING, MORRISTOWN, N. J. 10

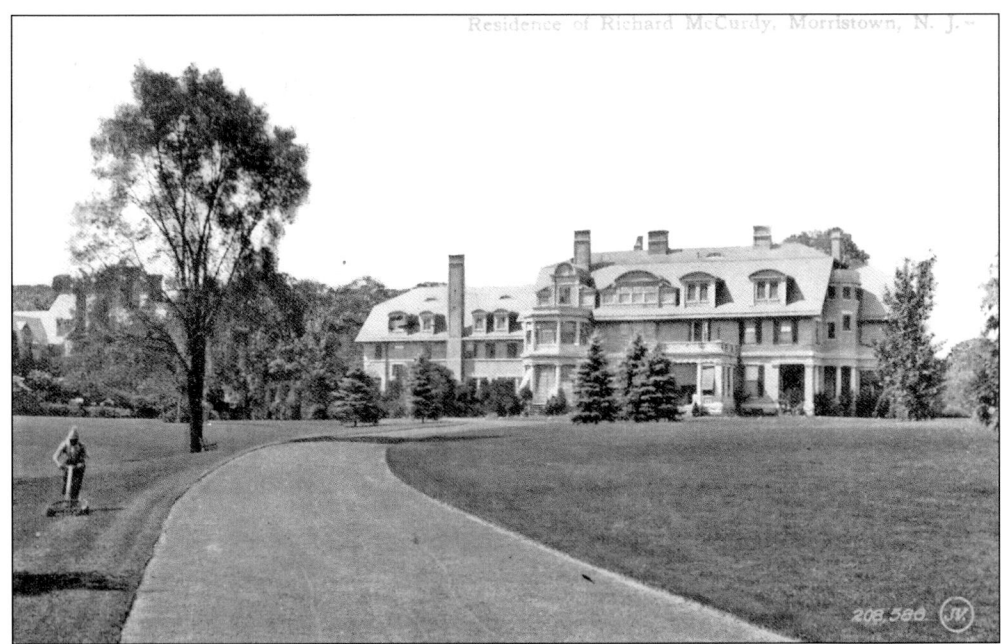

Richard McCurdy was the president of Mutual Insurance Company from 1885 to 1906. He resigned following an insurance investigation into his salary and the salaries given to his family members. His family was sued by Mutual Insurance and paid a settlement of $815,000. His mansion on South Street was made of yellow brick and gray stone and had 62 rooms. The building is now the site of the Blair House apartments.

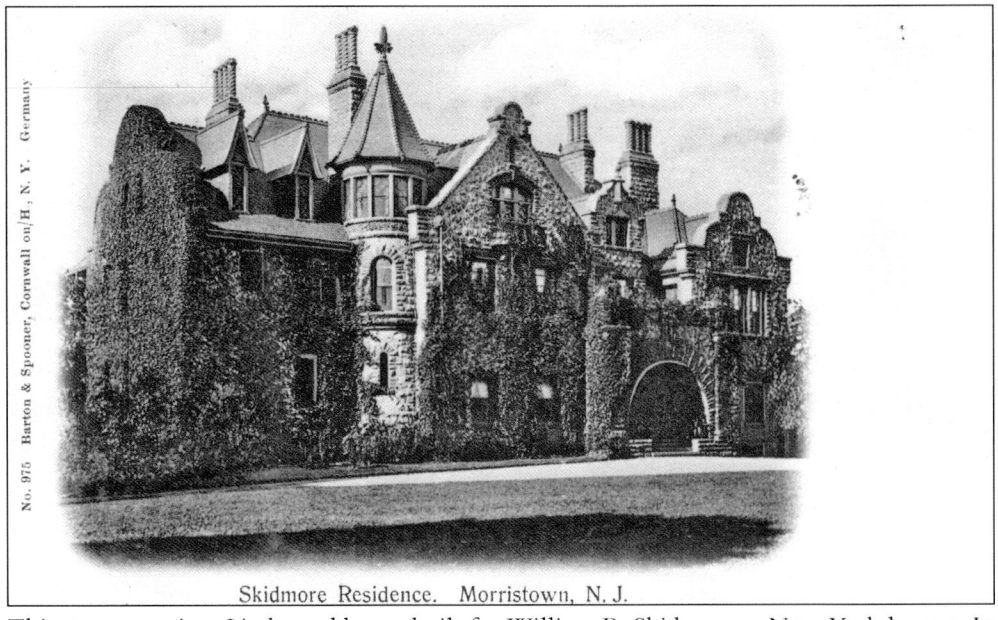

This stone mansion, Lindenwold, was built for William B. Skidmore, a New York lawyer. In 1905, the home was sold to John Claflin, a dry-goods merchant. Claflin formed the United Dry Goods Company, which ultimately became the May Corporation. He was a founder of the famed Jekyll Island Club, an exclusive millionaires' resort off the coast of Georgia. Today, the mansion is part of the Peck School. (Lewis Feldman.)

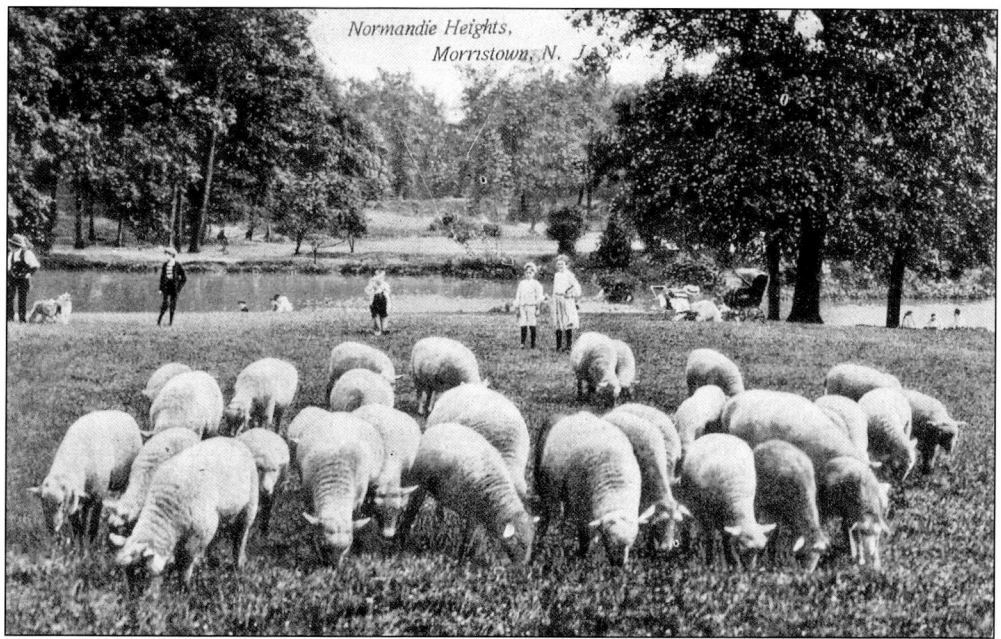

The Normandy Heights residential district was developed by local real estate developer John D. Canfield. Canfield founded the Morristown Land and Improvement Company in 1890. He laid out Normandy Heights Road and Normandy Parkway and sold large lots to wealthy men, ranging from Charles Armour to Peter H.B. Frelinghuysen. Many of the estates featured gentlemen's farms where sheep helped to tend the extensive lawns. (MCL.)

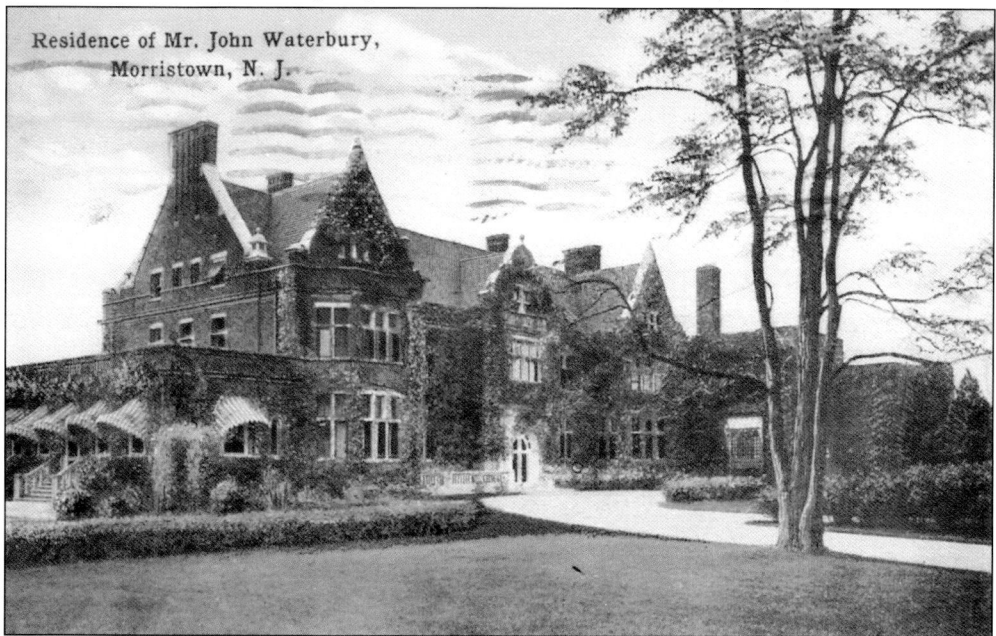

John Waterbury, a railroad magnate, purchased 60 acres of land from the Morristown Land Improvement Company. He built his home, Fairfield House, on the corner of Madison Avenue and Old Glen Road in 1899. Designed by John Mead Howells, the mansion had 18 bathrooms and 18 bedrooms. It is now the site of a bank.

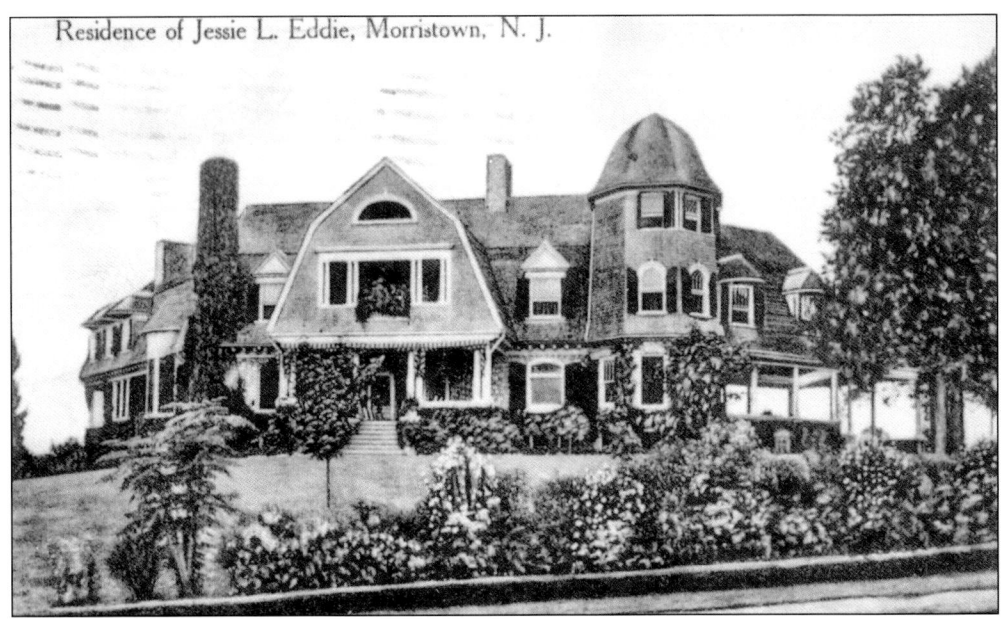

Valley View was the residence of Jesse Leeds Eddy, Joseph Dickson's partner in the anthracite coal company Eddy and Dickson. Eddy built this residence on Normandy Heights Road in 1896. The mansion had an elaborate great hall, numerous bedrooms, and servant's quarters on the third floor. The home is still standing and remains a private residence. (Lewis Feldman.)

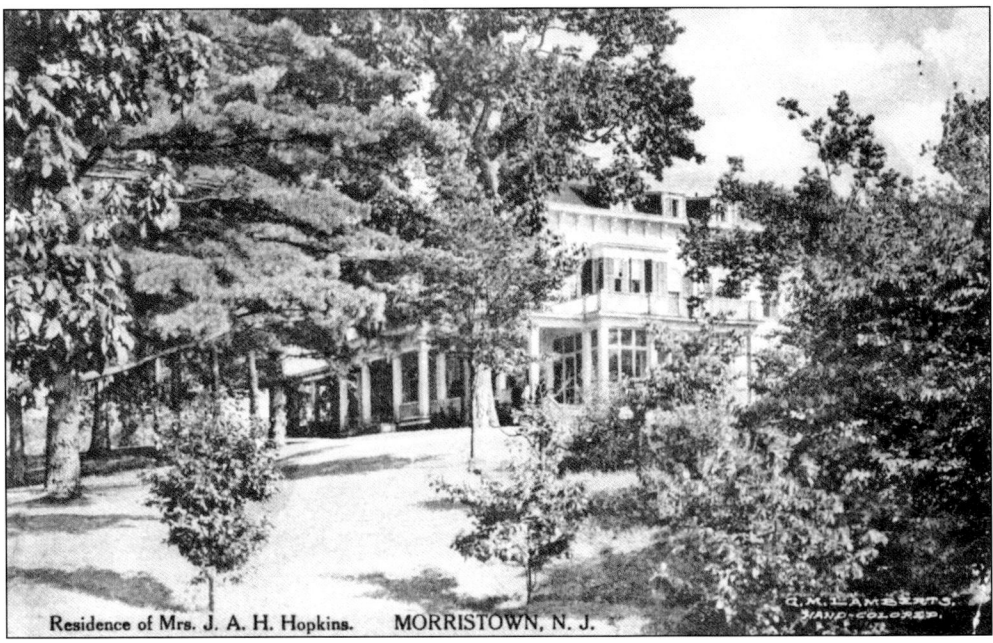

John A.H. Hopkins was an insurance magnate who named his estate on Normandy Parkway Featherleigh Farm. Hopkins's wife, Alison Low Turnbull Hopkins, was prominent in the women's suffrage movement. She was part of a group of women known as the "silent sentinels," who picketed Woodrow Wilson's White House. She was arrested and sentenced to 60 days at Occoquan Workhouse in Virginia. Her husband, who was friends with President Wilson, arranged her release. (Lewis Feldman.)

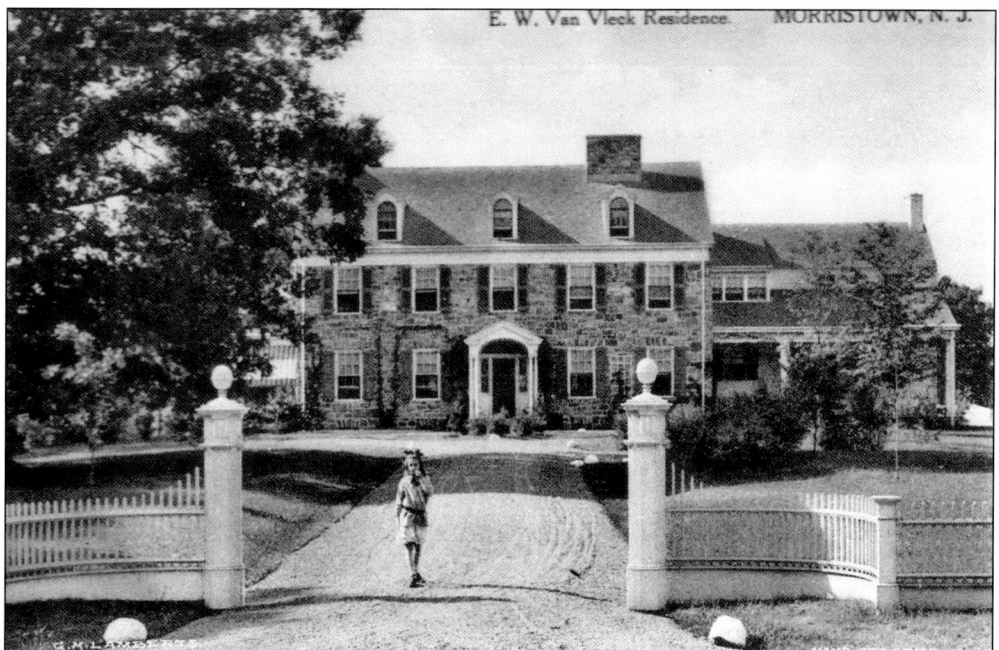

Edgar W. Van Vleck built his Normandy Parkway home, the Crossway, in 1905. It stands out as one of the few homes in the area built of stone at that time. Architects have dubbed the style "Delaware Valley" Colonial. The property extended to Columbia Turnpike. Behind the house were gardens, a carriage house, and a barn. Today, it is a private residence.

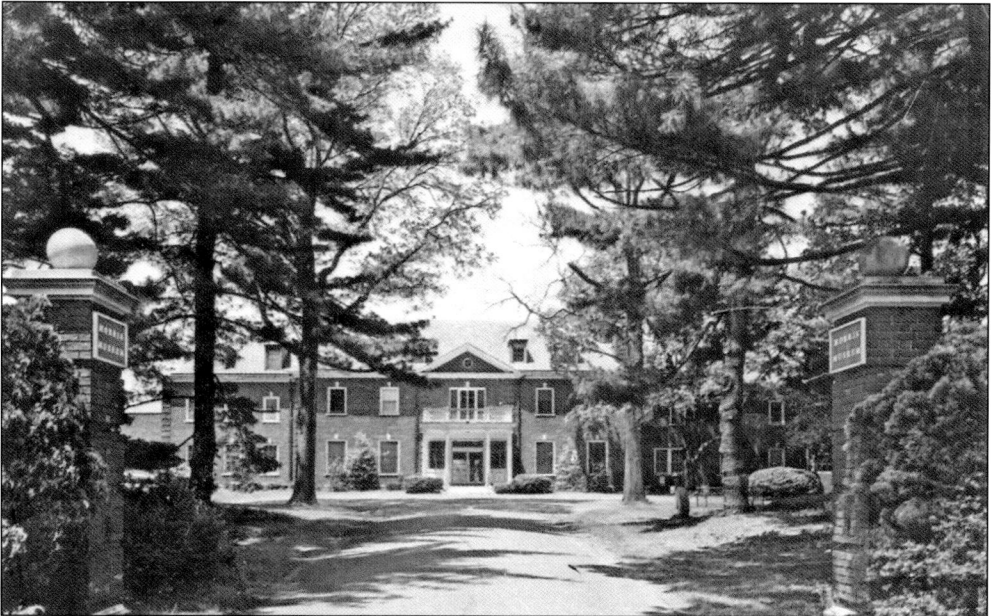

Twin Oaks Farm was the residence of Peter H.B. Frelinghuysen Sr., a lawyer, banker, and member of the storied Frelinghuysen family. Built in 1909 and designed by the Boston firm of Rotch and Tilden, the estate included 150 acres and was renowned for its herd of prize-winning cattle. The residence became the home of the Morris Junior Museum, now the Morris Museum.

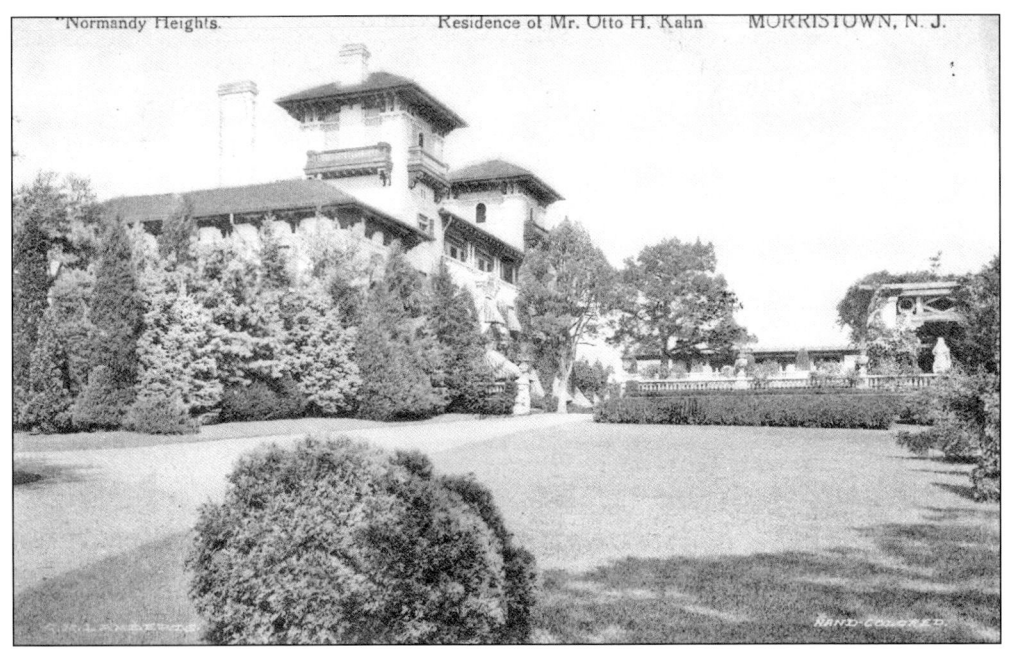

In 1897, New York banker Abraham Wolff bought 150 acres in Morris Township. He built two identical mansions for his daughters Adelaide and Clara. Adelaide was married to Otto Kahn, one of the country's wealthiest men. Kahn added elaborate farm buildings to the property, which also featured gardens, a deer paddock, and an 18-hole golf course. The mansion was rebuilt after a fire in 1905 and later opened as the Physiatric Institute for the treatment of diabetes. (Above, Lewis Feldman.)

Philip Kearny named his Columbia Turnpike mansion Only a Farm. Kearny was a New York banker, not to be confused with the Civil War major general Philip Kearny for whom the city of Kearny, New Jersey, is named. The mansion is no longer standing. (Lewis Feldman.)

This is an image of 68 Miller Road, the Moorings, which was the home of John C. Williams at the time this card was published. Built on Macculloch Avenue in 1867, it was later moved to Miller Road and altered between 1900 and 1910. The home is an example of how some of Morristown's existing homes were made more elaborate during the Gilded Age. It is still a private residence. (Lewis Feldman.)

L. C. Gillespie Residence, Picatinny Road. MORRISTOWN, N. J.

Gillespie's Tower, Morristown, N. J.

Louis C. Gillespie, an importer of China wood oil, purchased 115 acres of property in Morris Township in 1878 and constructed a summerhouse. Because of its elevation, the property featured magnificent views of the area. In 1890, Gillespie replaced the original home with a brick and marble mansion in the Colonial Revival style. The home featured beautiful woodwork carved from oak and mahogany. The large stone tower was added to the property in 1894. It was built to house a 417-foot-deep well and steam engine that supplied the property with water. A water storage tank was located on the fourth floor, and above that was a lookout room. The Gillespies allowed their neighbors to climb the tower, and it became a popular picnic spot for Morristownians. The estate is now home to the Villa Walsh Academy, a school for girls.

The estate of Henry E. Niese, known as Hill Terrace, was adjacent to the Gillespie estate. Niese was the general manager of the American Sugar Refining Company and held several patents for the sugar refining process. Niese was one of the defendants in an antitrust suit brought by the US government. The property was later bought by John H. Packard and destroyed by fire. (Lewis Feldman.)

This 34-room mansion was known as Glimpsewood Manor. Alfred R. Whitney was an iron and steel merchant whose firm supplied the ironwork for Grand Central Station. He established the Egbert Hill area of Morristown, between Sussex Turnpike and Washington Street, when he purchased a 38-acre tract of land from Maria Egbert. The property included stables, a carriage house, barns, greenhouses, eight employee cottages, a tennis court, gardens, and a private golf course (Lewis Feldman.)

Robert D. Foote was a prominent Morristown businessman who served as president of the National Iron Bank, among other local concerns. In 1902, he commissioned his brick and Indiana limestone mansion facing James Street. The property included acres of gardens and many outbuildings. Foote, an avid sportsman, is credited with bringing some of the first Springer Spaniels to America. The property served as inspiration for artist A.B. Frost, who used the estate in many of his illustrations. Farther down James Street was Morristown's Irish community, known as Little Dublin. By 1910, nearly all of Foote's employees were Irish. In 1921, Foote leased part of the property to the Spring Brook Country Club, which is still in existence. In 1927, the mansion and 20 acres of land became home to the Loyola House of Retreat.

James T. Pyle made his fortune from Pyle's Pearline, an early detergent. An 1889 advertisement claims that it could be used to wash everything from laundry to oil paintings. His estate, known as Hurstmont, was largely rebuilt in 1902 and 1903 by McKim, Mead, and White. Once listed as one of the "10 Most Endangered Historic Sites in New Jersey" by Preservation New Jersey, it was purchased in late 2011 and may be turned into condominiums. (Lewis Feldman.)

This image of a golfer and his caddy, labeled "On the Golf Links," could have represented any number of local golf courses, including ones at the Morris County Golf Club, the Morristown Field Club, the Spring Brook Country Club, or even the estates of Alfred Whitney or Otto Kahn, both of whom had private golf courses. One thing is certain: the rich of Morristown embraced the sporting life. (Elliott Ruga.)

The Morristown Field Club was founded in 1881 and is the third-oldest tennis club in New Jersey. In 1905, it was home to the first open New Jersey State Tennis Tournament, an event that was held until 1916. The annual horse show, begun in 1897, was a highlight of the social season, with private boxes for the event sold at auction. The club was originally located on the South Street property of William Skidmore and later moved to its current location on James Street. It also featured a variety of other sports, including baseball, football, cricket, target shooting, croquet, pool, golf, and ice-skating. Not only was it a playground for the wealthy, children from the nearby Little Dublin Irish immigrant neighborhood would play on the grounds, only to be run off by the caretaker. (Below, Lewis Feldman.)

The Morris County Golf Club was founded by a group of Morristown's leading society women in 1894, led by Nina Howland, Flora Twombly, and Mrs. William Shippen. Victims of their own success, the women were ousted from leadership in 1896. For many years, the club was central to the nation's golf scene, as numerous national amateur championships for both men and women were held there. These two images show the first clubhouse, located on Madison Avenue, which burned down in 1903. The clubhouse was then moved to the former Max Schmidt residence, where it remained until this too burned in 1915. The current clubhouse opened in 1919. The golf course layout meant that players and spectators had to cross railroad tracks to complete the course. For this reason, part of the property was sold to the College of Saint Elizabeth, and the entire club is now located on the north side of Punch Bowl Road.

Entrance to Whippany River Club, MORRISTOWN, N. J.

The Whippany River Club was formed in 1903 by a group of 12 Morristown millionaires. They leased the estate of Eugene Higgins, known as "the most luxurious unmarried man in America." Higgins's mansion had been destroyed by fire in 1902, but the property retained a grandstand with a one-half-mile track around it, polo field, and sports complex. The centerpiece of the club was the sports stable, which had one wing for horses and another for carriages and other vehicles. The property also included tennis, racquetball, and croquet courts. The club was located where the Mennen Company and Morris County Park Commission are today.

Interior "Whippany River Club". Morristown, N. J.

During its brief existence, the Whippany River Club was the place to see and be seen. Elaborate carriages, complete with coachmen and footmen, arrived at the gates. The activities of the club were given detailed accounts in the *New York Times* society pages, which reported on May 8, 1904, "From the activity displayed at the Whippany River Club it is evident that that organization means to succeed and progress this year." (MCL.)

45

WHIPPANY RIVER CLUB, MORRISTOWN, N. J.

After a 1910 fire destroyed the elaborate clubhouse, the Whippany River Club moved into this "cottage" on the Higgins estate. A new and improved polo field was added to the property. The Whippany River Club was a victim of the Great Depression. All that remains are its crumbling gates on Corey Lane.

Four

DOWNTOWN SCENES

The heart of Morristown has always been the Green, also called the Park. Speedwell Avenue, Mount Kemble Avenue, South Street, Morris Street, and Washington Street all radiate from the Green toward Morristown's neighborhoods and neighboring towns. The images on the following pages follow South Street to the Green, around West and North Park Place, up Speedwell Avenue, continuing on to East and South Park Place, and finally up Washington Street. Images of individual businesses follow. (Lewis Feldman.)

SOUTH STREET, FROM DE HART STREET, MORRISTOWN, N. J.

These two images show South Street from the corner of DeHart Street around 1916. Among the businesses that would have been located on the left side were a book and stationary store, a men's clothier, a drugstore, a grocery, a bakery, an art stationary store, a tailor, and a notions shop. On the right side were the offices of the Pocono Mountain Ice Company, a furniture store, a shoe store, a cigar and newsstand, and another grocery. In the below image, the sign for automobiles may have referred to either the John H. Schmidt Company or F.A. Trowbridge Company, both of which were listed as automobile dealers in the Morristown city directory. (Below, MCL.)

This c. 1900 image is mistakenly labeled as Washington Street, but is really an image of South Street from the corner of DeHart Street. On the far left is 21 South Street, known as the Savings Bank building. According to the 1897–1898 city directory, in addition to the bank, it was also the home of the Board of Fire Wardens, the Board of Excise Commissioners, and the offices of the Morristown Gas Light Company.

Henry M. Smith's drugstore was located on the left corner of South Street and Park Place in this c. 1900 image. Further along South Street on the left side was 10 South Street, Edward F. Coonery, wholesale liquor dealer. The building at 12 South Street was home to butcher William H. Hibler's business. The 1896 Sanborn insurance map shows a sausage factory in the back of 12 South Street, which was probably part of Hibler's establishment. (MCL.)

WEST PARK PLACE LOOKING TOWARD WASHINGTON ST, MORRISTOWN, N.J.

The buildings situated on the west side of the Green have changed numerous times over the years. The area has been the site of the New Jersey Hotel, Wilbur Day's Town House restaurant, D.P. McClellan dry goods, and Epstein's department store, shown here in its earlier incarnation, the Fair. This photograph shows an early stoplight and cars parked perpendicular to the Green and storefronts, something unimaginable today. (Lewis Feldman.)

This photograph from the 1960s showcases Epstein's department store, built in 1956, which replaced an earlier structure. Established in 1912 by Maurice and Rose Epstein, it is still fondly remembered by local residents. Shoppers could purchase everything from wine and cigars to furniture and clothing. It was torn down in 2006, and 40 Park, a complex of condominiums, restaurants, and storefronts, opened on the site in 2010. (Lewis Feldman.)

PARK PLACE, MORRISTOWN, N. J.

This c. 1916 postcard, looking toward Washington Street, shows Park Place. The corner of Market Street is on the far left side. Located on the corner of Market and Park Place was the Morristown Trust Company. Its board of directors was a virtual who's who of powerful men in Morristown, with names like Louis A. Thebaud, G.G. Frelinghuysen, Otto Kahn, and Richard McCurdy.

WASHINGTON ST. FROM PARK PLACE, MORRISTOWN, N. J.

This postcard illustrates the corner of Washington Street and Park Place. On the right is the five-story Babbitt Building, known as Morristown's skyscraper. According to the 1911 directory, it was home to Clarence C. Bockover, boots and shoes; B.W. Crane, dentist; Franklin W. Hartenstine, optician; the Johnson Pharmacy; Prudential Insurance; and H.A. and G.E. Babbitt, clothiers. On the left is the Bell Building, situated at the corner of Park and Bank Street. (MCL.)

This c. 1916 image shows Park Place toward Speedwell. Trolley tracks can be seen on the right side of the street. On the left are the Babbitt Building, the Parker Building, the Hoffman Building, and the United States Hotel. The building at 17 North Park Place, seen in the center of the street, was A.G. Philips & Sons general hardware, which specialized in agricultural equipment. There were two coal companies, Pruden & Burke at 17 North Park Place and Consumer's Coal in the Hoffman Building.

This wonderful real photograph postcard documents Park Place during some long forgotten patriotic event. The decorations may have been for the Fourth of July, the annual Firemen's Parade, or some other celebration. Not only are buildings decorated, but the men, women, and children are all smartly dressed in warm weather clothing. (Lewis Feldman.)

North Side of Square. MORRISTOWN, N. J.

A combination of early cars and horse and carriages dot this image of Park Place on the north side of the Green around 1913. Left of center is the tall Babbitt Building, and to the right of it is the Parker Building and the Farrelly Building. Behind the row of storefronts was a series of storage warehouses, an automobile garage, a candy factory, and an ice cream creamery. The United States Hotel is visible on the far right.

This 1960s image of Park Place is a stark contrast to the previous scenes. Shown here are several businesses that local residents may remember, including Jodo Gift Shop, S.S. Kresge Company (which later became Kmart), Rogers Clothing, and the building on the far right, Bamberger's department store. Several of these buildings have been modernized. The building at 10 Park Place, located on the right of S.S. Kresge & Co. was renovated in 2001, and a fifth-floor glass penthouse was added.

This postcard features an 1850s painting by local artist Edward Kranich. One of several scenes of Morristown painted by Kranich, it depicts the corner of Speedwell Avenue and Water Street near the Green. Century 21 department store currently occupies the site on the far left of the image. The painting is part of the collection of the Morris County Historical Society and is on view at Acorn Hall. (MHHM.)

This c. 1910 image of Speedwell Avenue shows an early streetlight and a trolley in the distance. On the left side is the McAlpin building, also known as the Merchant Block. The first floor was occupied by a number of storefronts, including S.B. Carson Dry Goods. The third floor housed Washington Hall, a large public speaking area that hosted everyone from Frederick Douglas to Thomas Edison. It was also the site of numerous private parties and public meetings.

SPEEDWELL AVENUE, MORRISTOWN, N. J.

These two images highlight the early-20th-century businesses of Speedwell Avenue. At the time, it was known by many in the Jewish community as "the Avenue," and was home to numerous Jewish-owned businesses. Stiner Brothers Grocers occupied 22 Speedwell Avenue, selling groceries, wine, and liquor. Salny Brothers, opened by two Jewish immigrants from Lithuania, specialized in men's clothing and was located at 30 Speedwell Avenue. Salny Brothers later moved to 36 Speedwell Avenue, where it remained in business until 1989. Just visible in the above image are signs for the Speedwell Restaurant and Roth and Company Meat Market. Farther down Speedwell Avenue, the Morristown Jewish Center was dedicated in 1929. Today, the area is home to many businesses operated by Hispanic immigrants. (Above, New Jersey State Library; below, Lewis Feldman.)

Speedwell Avenue, showing Methodist Church, Morristown, N. J.

Speedwell Ave., Morristown, N. J.

This is a later image of Speedwell Avenue. The McAlpin building (left) was torn down in the 1940s to make way for Bamberger's department store. Bamberger's, later Macy's, closed in 1993, and the fate of the building was uncertain for many years, until Century 21 department store opened in the space, continuing the tradition of retail business at the corner. The octagon-shaped building on the right was home to police headquarters.

Fountain at James Park, Morristown, N. J.

The fountain at James Park was installed by the Davis Granite Company, which also carved the Civil War monument on the Green, in 1907. It was donated by local philanthropist D. Willis James. The image shows a drinking fountain, and, below it, a water basin for dogs. The other side of the fountain had a larger basin for horses. The fountain is still in existence, standing in front of the 1776 building. (MHHM.)

On the left in these two images is the Lyons Theatre, later known as the Park Theatre. Prior to the construction of the Community Theatre, it was the most upscale of three movie theaters in Morristown. The theater featured both movies and vaudeville acts. An advertisement ran in the October 25, 1925, *Jerseyman* newspaper for Cecil B. DeMilles's *The Ten Commandments*. The same advertisement noted that seven vaudeville acts were scheduled to perform. The public bus station was located at 78 Park Place; a bus can be seen on the right in the image below. For many years, a small coffee shop located in a tiny, shed-sized building catered to commuters. The post office can be seen on the right in both images. (Above, Elliott Ruga; below, Lewis Feldman.)

PARADE OF MORRISTOWN FIRE DEPARTMENT—SEPT. 28, 1904

H. G. EMMELL, PUB., MORRISTOWN, N. J.

These two cards portray the annual Firemen's Parade on South Park Place, passing the Civil War monument. The parade was an annual Morristown tradition for many years. The horse-drawn pumpers, pulled by horses named Tom and Jerry, were a popular part of the parade for many town children. At one time, Morristown had six different fire companies, both volunteer and professional. The first professional firefighters were employed in 1867. In later years, a highlight of the parade was the mock rescue of a doll from the fifth floor of the second Babbitt Building on the corner of North Park Place. At the time, its five stories represented the tallest building in Morristown. (Above, MHHM; below, Elliott Ruga.)

Firemen's Parade Passing the Soldiers Monument, Morristown, N. J.

This c. 1900 image highlights the Green and Park Place. In the left background is the Methodist church. Next to the church was the business of William Kay, who specialized in plumbing and slate and tin roofing. He had a tin shop behind his storefront. The building at 44 Park Place was home to the New York and New Jersey Telephone Company. (MCL.)

An apothecary was opened on the corner of South Street and Park Place by Frederick King in 1825. Following several different owners, the site was taken over in 1880 by Henry Smith, who operated it until 1923. This image shows the soda fountain that, according to a local newspaper account, was enlarged several times and, at one point, was 35 feet long. The offices of the Postal Telegraph–Cable Company were located upstairs.

Washington Street, Morristown, N. J.

These two images highlight Washington Street during the turn of the 20th century. On the right side, 24 Washington Street was the business of Willis H. Dutton, who advertised automobile sales (Oldsmobile and Cadillac) and repair, bicycles and sundries, and machinist, electrician, and locksmith services. There were two newspapers: the *Morristown News* at 4 Washington Street and the *True Democratic Banner* at 12 Washington Street. Also on the right was 20 Washington Street, Schweikhardt & Son Meat Market; jeweler James S. Hall was also at 24 Washington Street. On the left was Karn & Eichlin grocers at 11 Washington Street, Albert Bowman's cigar and newsstand at 15 Washington Street, confectioner Antonio Butera at 19 Washington Street, and the Family Lunch Room at 27 Washington Street. Perhaps serving the Italian immigrant community, Vincent Azzara was listed in the 1905 directory at 19 confectioner as a teacher of Italian and interpreter. (Both, Lewis Feldman.)

Washington Street, Morristown, N. J.

In the lower right corner of this 1975 image is the 1776 Building. It was the first part of Morristown's urban renewal program of the 1970s. The parking area behind the building no longer exists. In 1977, a new street was built under the complex, connecting Spring Street with Speedwell Avenue and the Green. (MCL.)

At the top center of this image is the Headquarters Plaza complex. Built between 1980 and 1985, the urban renewal project, dating back to the 1960s, remains controversial to this day. Numerous old and historic buildings were razed in anticipation of the project. The complex also divided the area known as "the Hollow," traditionally a poorer neighborhood, from the center of town. Today, the complex includes offices, a parking garage, the Hyatt hotel, a movie theater, and some restaurants. (MCL.)

The Gift Shop, owned by Alexander Bennell and Frank Burnett, was located at 15 South Street. According to its listing in the 1917 city directory, the store specialized in a variety of gift items, many of which can be seen in this postcard image. It also featured a circulating library and "society and commercial stationary." The shop closed after being gutted by fire. (Lewis Feldman.)

J.E. Parker started his business as jeweler and optician in 1865. The business was later taken over by Parker and Van Cleve. It was located at 22 Park Place in what was known as the Parker Building. They erected a new building at the location in 1903. Just down the block was I.D. Lyon, jeweler and optician, whose business passed through many hands before closing in 1986. (MCL.)

The National Iron Bank was founded in 1855 as the Iron Bank of Rockaway. Over the years, the list of bank officers was filled with the names of Morristown's most rich and powerful men. Originally located on Washington Street, this branch was built in the Classical Revival style in 1911. While the National Iron Bank is gone, the building is still in operation and home to a bank.

The Morristown Trust Company designed their fourth location to be reminiscent of the Governor's Palace in Williamsburg, Virginia. In keeping with the historical theme, they hired Francis Scott Bradford to paint a mural of Washington's Morristown encampment. Bradford was a nationally recognized mural artist who painted murals in office and government buildings across the country. The building is still a bank, and Bradford's mural can be seen behind the banking counter.

The structure at 83 South Street is one of the oldest original residential buildings remaining on the street. For approximately 80 years, it was home to the Book Shop, which first appeared in the city directory in 1921. It was purchased by the Friends of the Library in 1995 and restored during the library's most recent expansion. It is now rented out as office space. (Pam Hasegawa.)

The Community Theatre opened on December 23, 1937. Built during the Great Depression, it brought much-needed jobs to the community. It was advertised locally as "America's most beautiful theater," but fell into decline in the 1970s. It found new life in 1994, when a group of dedicated volunteers worked to reopen it as a performance theater. Today, it is home to the Mayo Center for the Performing Arts. (Pam Hasegawa.)

Five
CHURCHES AND SCHOOLS

In the earliest days of Morristown, residents traveled to the Hanover Presbyterian Church to worship. As Morristown grew, the need for its own church led a group of congregants to form a new church in 1738. The church owned a remarkable amount of land, stretching from Maple Avenue to the Whippany River and South Street to Pine Street. This steeple still stands in the cemetery behind the church. (MHHM.)

The third home of the First Presbyterian Church was built in 1893 and 1894. The new church was designed by the architect J. Cleveland Cady, who had also designed the American Museum of Natural History and the original Metropolitan Opera in New York City. Directly behind the church is the graveyard, which has a rich history and features many early gravestones.

The first minister of the church, Timothy Johnes, built a home on Morris Street; that building later became the first home of Morristown Memorial Hospital. In 1886, the Manse was designed by local architect Louis Hazeltine, who also designed the home that became the Peck School and several houses on Farragut Place. (MHHM.)

The First Baptist Church was first organized as a congregation in 1752 and worshipped in a meetinghouse on Mount Kemble Avenue. The congregation later met in the courthouse on the Green. This building was erected in 1771 near the current location of 10 Park Place. The structure was used as an Army hospital in the Revolutionary War during the winter of 1777–1778.

The Romanesque Revival home of the First Baptist Church was built on Washington Street in 1892 and dedicated in 1897. Sadly, a fire devastated the structure in 2001. The church building committee chose to rebuild the structure in the original Victorian style, utilizing the brownstone foundation that remained after the fire. Today, the church is also home to a Latino ministry.

Old St. Peters Church (now destroyed), Morristown, N. J. aug. 9 -/0

THIS IS THE CHURCH WHICH WAS DESIGNED BY STANFORD WHITE WHO WAS MURDERED BY HARRY THAW

St. Peter's Episcopal Church was incorporated in 1827, and the ground breaking for this church took place in 1828. Morris County's early iron industry had brought numerous settlers of English background, many of who were part of the Anglican church. Early church records indicate that services were sporadically held in Morristown as early as 1760, and by 1810, services were held in the home of George Macculloch. (MHHM.)

A building committee was formed in 1886 to begin a new St. Peter's. The famed New York architectural firm of McKim, Mead & White were hired as architects, and in 1887, the cornerstone was laid. Construction of the church continued for the next 24 years because the church would not erect any portion of the building unless it could be fully paid for.

70

ST. PETERS CHURCH, MORRISTOWN, N. J.

St. Peter's was the church of many of Morristown's Gilded Age residents. It was the site of elaborate society weddings, although one of the least elaborate weddings was held for the daughter of one of the world's wealthiest women. Sylvia Green, daughter of Hettie Green, known as the notoriously frugal "witch of Wall Street," married Matthew Astor Wilks, a grandson of John Jacob Astor, here in 1909.

"Church of the Redeemer". South St., Morristown, N. J.

A split in the congregation of St. Peter's led to the formation of the Church of the Redeemer in 1852. This church was constructed on the corner of Morris and Pine Streets in 1853 and moved to South Street in 1886. The current stone building was erected in 1917.

Greetings from Morristown, N. J.

H. G. Emmell, Publisher, Morristown, N. J.

In 1841, a group of parishioners of the First Presbyterian Church petitioned to create a new church. They erected their new church on South Street. In 1877, that building was destroyed by fire, and the Romanesque Revival church shown here was constructed. It was also designed by renowned architect J.C. Cady in 1926. The First Presbyterian Church and South Street Presbyterian congregations reunited, and the South Street Presbyterian Church building now serves as additional space for church activities. (Lewis Feldman.)

The Methodist Church in Morristown dates to 1826. Construction of this building began in 1866 and was completed in 1870. It was constructed of local puddingstone, a unique local stone that has a purple hue. The church suffered a fire in 1972 that left only the tower and front wall standing. Like the Baptist church, it was rebuilt utilizing the remaining facade.

73

Assumption Church was the first Catholic church in Morristown. The first structure was built in 1848 and consecrated in 1849. The parish grew rapidly with the influx of Irish immigrants, many of who lived in the Little Dublin neighborhood surrounding the church. This building was consecrated in 1873. It was extensively reconstructed after a fire in 1985.

The Church of St. Margaret of Scotland dates back to 1885, when Father Joseph Flynn, pastor of Assumption Church, felt that a second Catholic church was needed in Morristown. The pastor convinced the bishop to purchase a 10-acre parcel of land at the junction of Sussex and Speedwell Avenue. He then auctioned off 63 building lots to raise funds to erect a chapel and repay the property loan. This postcard shows the interior of the 1968 building, which still stands today.

The Maple Avenue School opened in 1869 to replace several one-room schoolhouses located throughout the town and township. Local businessman and philanthropist George T. Cobb donated the lot and $10,000 in cash to be matched by taxpayer bonds. The school originally had three stories with 12 classrooms and an auditorium on the third floor. It accepted students of all grade levels, and communities outside of Morristown could send their students for an annual fee. These images show the original structure, as well as the 1892 addition. Famed poet Joyce Kilmer taught Latin at the high school level in 1908. The school was torn down in 1953 and is now the site of One Maple Avenue, Morristown's first green building. (MCL.)

1:—High School, Morristown, N. J.

For decades, Morristown's high school students attended the Maple Avenue School. A new high school opened in September 1918 and has been enlarged several times since then. The building was also briefly home to the Morristown Junior College, part of the Emergency Relief Administration under FDR. Famous graduates of the school include film critic Gene Shalit and Craig Newmark, the founder of craigslist. (MCL.)

GEORGE WASHINGTON SCHOOL, MORRISTOWN, N. J.

The George Washington School was built in 1927. It was one of a series of schools built in the first half of the 20th century to replace the outdated schools of the 19th century. It was torn down in the early 2000s and is now the site of a condominium complex. (MCL.)

Church records indicate that Morristown had a schoolhouse by 1767. Little is known about those early educational institutions until the development of the Morris Academy, which opened on South Street in 1792. A private school, it remained in operation until 1869, when the Maple Avenue School opened. The Morris Academy returned in 1878 as part of the Morristown Library and Lyceum. The school closed for good in 1914 after a fire.

The Morristown School, today known as the Morristown Beard School, was founded in 1891 as St. Bartholomew's School. One of the most notable graduates was John Reed, who wrote *Ten Days that Shook the World*, an eyewitness account of the Russian Revolution. The book was later adapted into the Oscar-winning film *Reds*. John Bouvier III, the father of Jacqueline Kennedy, also attended the school.

Morristown Seminary for Young Ladies, Morristown, N. J.

The Morris Female Institute opened in 1862 on South Street near the intersection of Madison Avenue. In 1877, the school was leased to Elizabeth Dana and became known as Miss Dana's School. Students included day students from Morristown and boarders from New Jersey and beyond. The school had a collegiate curriculum that included classes ranging from languages such as Greek and Latin to sciences such as chemistry and physics. The students were also expected to attend evening lectures that would expose them to social and political topics. The school was highly regarded, and students were guaranteed acceptance to Vassar College. Vassar College still awards the Elizabeth Dana Reading Prize, which was established in honor of Miss Dana in 1911. Her most famous graduate was Dorothy Parker, who graduated in 1911 as Dorothy Rothschild. The school closed in 1912. (Below, MCL.)

St. Elizabeth Convent. Convent Station, Morristown, N. J.

In 1860, the Sisters of Charity of St. Elizabeth established their motherhouse and the St. Elizabeth Academy for girls. In 1899, the College of St. Elizabeth was founded as one of the first Catholic women's colleges in the United States. The beautiful stone buildings were constructed mainly by local Italian immigrants. (Elliott Ruga.)

Six

PUBLIC INSTITUTIONS

Morristown's oldest public institution is the courthouse and jail. The original courthouse was built on the Green in 1755 on one acre of land set aside by the Presbyterian Church. The courthouse and jail were one structure; a guardhouse, pillory, and outhouse stood nearby. A new building was erected in 1771. During the Revolutionary War, local loyalists were rounded up and housed in the jail on the Green. A new courthouse and jail were built in 1827.

Monument showing spot where Old Court House stood during the Revolution, Morristown, N. J.

COUNTY COURT HOUSE, MORRISTOWN, N. J BUILT 1827.

In 1826, the cornerstone for the Morris County Court House was laid on a piece of property on Washington Street that the County Freeholders purchased for $100. Additional wings were added to the structure during the 19th century. The distinctive puddingstone fence was installed in the early 20th century. One of the building's most unusual features is the statue of a female representative of Justice, who, unlike most of her counterparts on courthouses across the country, is not blindfolded. Courtroom No. 1, the original courtroom, is still in service, and few changes have been made to it since 1827. (Above, MCL.)

THE MORRIS COUNTY COURT HOUSE. BUILT IN 1826. MORRISTOWN, N. J.— 3

The Morristown Library and Lyceum was built between 1875 and 1879 and designed by New York architect George B. Post. It housed the Morris Academy, a 50,000-volume library with a public reading room, a second-floor audience hall with seating for 800, and a ballroom. Originally a private institution, books were free to everyone following a generous donation by William B. Skidmore. The Lyceum played host to a veritable who's who of the 19th century. Local diarist Phoebe Lindsley Thatcher saw Arthur Conan Doyle speak there, noting "a most self-satisfied man." The building was also used for many of the lavish parties of the local elite. It burned in 1914 and then became the home of the Morristown Armory, as seen in the image below. It was razed in the late 1930s.

All Soul's Hospital opened in Morristown as a Catholic hospital in 1892. The hospital was first housed in the former Arnold's Tavern building, which was originally located on the Morristown Green and served as Gen. George Washington's headquarters during the winter of 1777. The building was moved to Mount Kemble Avenue, where it was the hospital's home until it was destroyed by fire in 1918. A new hospital building opened in 1919. In 1978, all Soul's Hospital was acquired by Morristown Memorial Hospital, which still maintains All Soul's as part of its campus.

Morristown Memorial Hospital was Morristown's second hospital, founded shortly after All Soul's. The original hospital was located in the former Johnes parsonage, built in 1750. A separate structure known as the Annex was built in 1895. The above image shows the 1898 hospital building constructed across the street from the original hospital. It was three stories tall and contained 28 beds. The postcard below shows one of the first additions to that building; two new wings had been added by 1910. The hospital continued to grow and has become one of the largest hospitals in the region. It is now known as Morristown Medical Center. (Above, MHHM.)

The Corner Store was a food and gift shop operated by the Morristown Memorial Hospital Woman's Association. The association is as old as the hospital itself. Today, it operates three gift shops, four sites of the Au Bon Pain café, and the Bargain Box Thrift Shop. The organization's biennial Mansion in May designer house show is a major fundraiser and popular local event.

Originally known as the New Jersey State Lunatic Asylum at Morristown, Greystone Psychiatric Hospital is located just outside of Morristown. The Kirkbride building, based on the design of Dr. Thomas Kirkbride, was constructed in 1878 and was considered a model of modern construction. The building was the centerpiece of an entire self-sustaining campus that included its own post office, dairy, farm, fire department, gas plant, and other facilities. (MHHM.)

Tel. MOrristown 4-3260 AURORA — Aerial View Morristown, N. J.

The Aurora Health Farm was founded in 1920 by Dr. Schulman and his wife. They built this Spanish Colonial Revival building in 1928. The health farm was suited to the treatment of a variety of conditions, ranging from anemia to hypertension. Prescribed treatments included electrotherapy, hydrotherapy, and light therapy. The large lobby was very similar to the lobby of a luxury hotel and featured an alcove with a fireplace that served as a reading room. The dining room was equally lavish. The building was later acquired by the county and is now operated by the Morris County Park Commission. Private patient rooms are now offices. The large public spaces are available for rental for meetings, parties, and cultural events. The veranda shown in the image below was removed by the park commission. (Both, Morris County Heritage Commission.)

Tel. MOrristown 4-3260 AURORA - The Veranda Morristown, N. J.

88

"Headquarters of the famous Seeing Eye of Morristown, N. J., where dogs are educated as guides for blind people."

The practice of using dogs to aid the visually impaired began in Europe in the 1920s. The Seeing Eye was established in the United States in 1929. Originally located in Nashville, Tennessee, the Seeing Eye was relocated to Whippany, New Jersey, in 1931. Just outside of Morristown, the estate on Whippany Road was an excellent site for the campus. In 1965, it moved to its new facility in Morris Township. The brick Georgian structure served as the main building. Training dogs and those learning to use them are a familiar site on the streets of Morristown. (Below, MCL.)

The Morristown YMCA was founded in 1874 by Thomas E. Souper and Dr. Frederick W. Owen, a Civil War veteran. The organization originally rented space in a building on Park Place. They purchased a lot on South Street in 1884 for $3,700, and this building opened in October 1888. A ladies auxiliary group was founded in 1883, but women were not given membership until World War I.

In 1909, the YMCA purchased a lot at the corner of Washington Street and Western Avenue for $14,000. The handsome new building opened in 1913, next to the Morris County Courthouse complex. The YMCA moved again in 1981 to its current facility on Horsehill Road. This building was renovated in 1982 and became known as the Courthouse Plaza office building.

Morristown's very first post office dates to the Revolutionary War, when a temporary facility opened in 1777. Mail came from Philadelphia once a week. Permanent service was established in 1782. The first postmaster was Frederick King, who was succeeded by his son Henry. The two men served for a total of 52 years. The building shown here was erected in 1916.

Seven
Transportation

Along the Lackawanna Railroad, Morristown, N.J.

In 1900, Morristown was served by three railroad companies: the Delaware, Lackawanna & Western Railroad Company (D&LW), once called the "dubious, lackadaisical and whimsical;" the Whippany River Railroad, later known as the Morristown & Erie; and the Rockaway Valley, known as the "Rockabye Baby." All three offered both freight and passenger service. The first two lines are still in existence, albeit in new forms; the Rockaway Valley ceased operations in 1914.

Train service came to Morristown in the early 19th century, when the Morris & Essex Railroad was chartered in 1835 to construct a line between Morristown and New York Harbor. Madison resident Judge Francis S. Lathrop was one of the first regular commuters. He applied for a six-month "right of free passage" in 1841, paying $100 for unlimited service. The DL&W Railroad built the station shown here in 1881. The station was the terminus of the famed "Millionaire's Express," which provided private service for the millionaires who called Morristown home and commuted to their offices in New York City. The image below captures a daily scene: coachmen lined up every morning and every evening to transport their wealthy employers back and forth between mansion and station. (Below, MCL.)

D. L. & W. R.R. Station, Morristown, N. J.

The current Morristown Railroad Station, pictured in these two early-20th-century postcards, was built in 1913 by the Delaware, Lackawanna & Western Railroad Company. It was designed by the company's architectural team, led by architect F.J. Nies and engineer G.J. Ray. It was built at a time when the company used its buildings to impress its stockholders. When the station opened, the *Daily Record* said that Morristown had "modern transportation facilities of which it can truthfully boast." Today, service to this station is provided by New Jersey Transit. Direct service to New York City was established in 1996; for the first time in over 150 years, local commuters did not have to make a transfer. This station is part of New Jersey's first transit village. (Below, MCL.)

9:—D. & L. W. R. R. Station, Morristown, N. J.

July 25 – August 5, 1929.

The Whippany River Railroad, later known as the Morris & Erie, was built to serve Whippany's extensive paper industry. It had its own station in Morristown, adjacent to the first Lackawanna station. It carried both freight and passengers and extended all the way to Essex Fells. At one time, the railroad offered Saturday night service so that mill workers could travel to Morristown to spend their leisure time.

In 1918, the Morris & Erie Railway added rail bus service. They purchased two buses that were fitted to run on rails in order to continue passenger service, which was steadily losing money. In 1928, passenger service ended. This rail bus can be seen at the Whippany Railway Museum, which also operates excursion trains, allowing people to travel the old route from Whippany to Morristown.

WHEN THE TROLLEY CAR CAME TO MORRISTOWN—Aug. 27,'09

The Morris County Traction Company was chartered in 1899. The line eventually stretched from Lake Hopatcong to Newark, New Jersey. Area residents who remember Bertrand Island Amusement Park may be interested to know that the park property was originally owned by the company, which developed it as a destination; the park marked the end of the trolley line. The trolley first arrived in Morristown on August 27, 1909, as noted on this postcard. (MCL.)

366 Park Place, Morristown, N. J.

In Morristown, the trolley went all the way around the Green. The tracks in Morristown were laid down by local contractor Eney Grupelli, who also built many of the apartments that housed Morristown's immigrant community. There were occasionally accidents involving the trolley. In 1926, the *Daily Record* reported on a crash near where the Jacob Ford Village apartment complex now stands. (Lewis Feldman.)

Here, the trolley is traveling on Park Place, heading toward Morris Street. The trolley was not part of the landscape of Morristown for very long. The tracks began to be removed in 1928, less than 20 years after the trolley came to town. An advertisement in a local newspaper informed riders that buses would be replacing trolleys on January 15, 1928. Today, all that remains is a two-mile trail maintained by the Morris County Park Commission in Morris Township. (Lewis Feldman.)

In Front of Morris Co., Golf Club, Morristown, N. J.

This jitney serving the Morris County Golf Club is indicative of the type of early bus service that was used in Morristown. The Morris County Traction Company supplemented its trolley service with jitneys such as this one. Over the course of the 20th century, a variety of companies provided bus service to Morristown, one of the earliest being the Morristown-Madison Auto Bus Company, which began service in 1912. (Lewis Feldman.)

Eight

Places to Eat, Sleep, and Drink

One of the earliest hotels in Morristown, this brick structure, located on Washington Street and built in 1864, replaced an earlier version of the Mansion House. It was considered very modern, having steam heat and gas lighting. It also had a stable in the rear to accommodate horses. The building was torn down in 1940, last serving as the site of Sears, Roebuck and Co.

UNITED STATES HOTEL, Morristown, N. J., A. E. Voorhees, Proprietor

The United States Hotel was located on Park Place in Morristown, where 10 Park Place is today. A full-service hotel, it featured a dining room and had a livery and boarding stable attached. It was also the starting point for passengers of the Rockaway Valley Railroad, who boarded a stage that took them to the railroad terminus near Lake Road and Lake Valley Road. The hotel was torn down in 1926.

Dining Room of Park Hotel, 16 South Street, Morristown, N. J.

The Park Hotel opened at 16 South Street in the 1920s as the Park Hotel and Restaurant. It was later called the Hotel Pranz. Eventually, it became known as Hotel 16 and offered low-income housing, with rooms renting for between $60 and $77 per week, according to a 1986 newspaper article. The building was converted into offices with a restaurant on the first floor. (MCL.)

The Morristown Inn was located on the corner of South and Pine Streets. It was operated as the Colonial from 1895 to 1905. It was then enlarged and renamed the Morristown Inn. The property was sold in 1937 to the American Community Theatres Corporation, which built the luxurious Community Theatre, regarded by locals as the "fancy" movie house. Eventually falling into decay, the Community Theatre was rescued by a committed group of local volunteers. Today, it is known as the Mayo Center for the Performing Arts. (Below, MCL.)

The house at 259 Speedwell Avenue, pictured above, was operated as Thompson's Tourist Home. It was established in 1932, and this card is postmarked 1936. Pictured below and three doors down at 265 Speedwell Avenue was the Evergreens, operated by William Beach. It featured large rooms with twin beds, steam heat, baths, and parking. The postcard noted, "Inquire here for points of historical interest."

The Hotel Revere, located on Community Place, opened in 1924 as the Du Mont Apartment Hotel. The name was changed in the 1940s. It featured a combination of traditional hotel rooms and multiroom suites with kitchenettes. In 1965, it was converted into an office and professional building, and is still one today.

The Governor Morris Hotel, opened in 1964, is located on the border of Morristown and Morris Township. When it opened, it was the largest and most modern hotel in Morris County. It has since been renovated several times; the tennis court in the image is long gone, and there is a new pool in a different location. It is now operated as a Westin Hotel.

WILBUR F. DAY
Caterers :: Confectioners :: Restaurateurs
Established 1862 40 Park Place, Morristown N. J.

Wilbur F. Day opened his restaurant at 40 Park Place in 1862. The business passed through three generations of the Day family. Day's, as it was known locally, also catered nearly all of the social events of Morristown's elite. Local legend has it that Milton Hershey worked at Day's before beginning his chocolate empire. In later years, it was known as the Town House.

Viedt's Confectionery and Lunch Room at 20 Park Place was opened in 1900 by German immigrant Herman Viedt. He manufactured his own ice cream using his patented "iceless method." He sold the business in 1921 to the Larabee Chocolate Shop, and then opened a business in Princeton. Viedt died of a heart attack in 1934.

Winchester's Turnpike Inn 217 South St., Route 24, Morristown, N. J.

This historic structure, the earliest portion dating back to 1749, first became a restaurant in 1946. Initially, it was called Winchester's Turnpike Inn and later became the Wedgewood Inn, pictured below. Younger residents may remember it as Phoebe's or Jimmy's Haunt. For many years, it was regarded as the most haunted building in Morristown due to the 1833 murders of its residents, Samuel and Sally Sayre, and their servant, Phoebe. Antoine LeBlanc, a French immigrant, was found guilty of the killings and was hanged on the Morristown Green. He was the last person to be publicly executed there. The building was demolished in 2007 and is now the site of a bank.

NEW YORK TEA GARDEN Chinese and American Restaurant 2 Washington St., Morristown, N. J.

The New York Tea Garden was probably one of the first Chinese restaurants in the Morristown area. It is listed at 24 Washington Street in the 1930 city directory and was taken over by Henry Lam in 1946. According to a 1969 newspaper article, the restaurant had seating for 375 people and banquet facilities for 200 more.

Located on Madison Avenue near the Madison border, Rod's 1890's Ranch House opened in 1951. It has been owned for several generations by the Keller family. In 1981, the Kellers expanded, opening the Madison Hotel, attached to the original restaurant. A second restaurant, G.K.'s Red Dog Tavern, opened on the property in 2011. (MCL.)

Nine
Parks and Recreation

Morristown's Green is one of the most historical aspects of the town. The Green was originally part of the land of the Presbyterian Church. It was used as grazing area for animals and as a source of water for local residents. In 1816, the land was deeded to a group of local citizens to be kept in public trust as common forever. It remains in the custody of the Trustees of the Morristown Green to this day.

The Green was not always the pristine landscape portrayed here. During the Revolutionary War, the War of 1812, and the Civil War, local troops used the Green for their exercises. In addition to the courthouse and jail buildings, a general store was located here in the early 1800s. In 1833, it was the site of the hanging of Antoine Le Blanc, who had been convicted of three grisly murders.

Improvements began on the Green in 1877, when curbing was added; flagged paths were created in 1885. The first overall scheme to improve the Green occurred in 1908, with a design by John Brinley. Restoration of the Green occurred in 1981 and 1982, including an archaeological dig conducted by a local university. Another restoration, which has won several awards, was carried out in 2007. (MHHM.)

The Park in Winter, Morristown, N. J.

Here, the Green and streets of Morristown are blanketed with snow. During the 1800s, locals were able to skate on the Green in the winter. A gully located in a low spot in the northeast corner, closer to Speedwell Avenue, was used for skating in the winter and swimming in the summer.

The Park. Morristown, N. J.

The Green has been a place to play for generations of Morristown children. In the 1840s and 1850s, the circus set up on the Green; in 1900, it was the site of minstrel shows. Christmas decorations appeared in the 1840s. The first organized Christmas celebration occurred in 1913, Santa came in 1940, and Santaland was added in 1948. Santa still returns to the Green every year, and family activities are sponsored by the Morristown Partnership.

The Civil War monument was the first monument erected on the Morristown Green. It was dedicated on July 4, 1871, by New Jersey governor Theodore Randolph. It features "Soldier at Rest" atop a memorial marker, surrounded by four real cannon. Two historical markers were added on November 11, 1904. One, installed by the Morristown Daughters of the American Revolution, documents the original courthouse. The second marker recognizes the Revolutionary War–era Presbyterian church. During World War II, a lighted gold star was added to a Norway Spruce, in honor of the mothers who lost children in the war. It was replaced and rededicated in 2010. Four additional statues have been added: Patriot's Farewell was unveiled in 2001, and statues of George Washington, Alexander Hamilton, and the Marquis de Lafayette were unveiled in 2007.

Soldiers Monument, Morristown, N. J.

115

Morristown, N. J. Mill's Pond

This image of the pond at Burnham Park predates the creation of the park in 1911. Local children enjoy the pond to cool off on a hot day. In the background, a building used to harvest ice in the wintertime can be seen. In the days before electric refrigerators, ice harvesting was big business, and nearly every local lake or pond was used as a supply source.

BURNHAM PARK LAKE, MORRISTOWN, N. J.

Burnham Park was created in 1911 when Frederick G. Burnham and his wife donated 30 acres of land to Morristown to be used as a public park. The Burnhams wanted to ensure that local residents would have an area for fishing, boating, swimming, and other recreation. Since 1948, the Burnham Park Association has worked to ensure that legacy. The organization have been hailed for its dedication to maintaining and protecting the park.

Thomas Paine is one of the less-remembered figures of the American Revolution, yet his 1776 publication *Common Sense* was an influential bestseller of the era. Despite his critical role in American history, he has not been memorialized to the extent many of his contemporaries have. His statue in Burnham Park, dedicated on July 4, 1950, is one of the few in the country.

Throughout much of the 19th century, Speedwell Lake was a major part of Morristown's industry; however, following the closing of the Speedwell complex, the lake became a more bucolic setting. During the first half of the 20th century, it was a favorite swimming hole. Today, it is bordered by Speedwell Lake Park and connected to the Patriot's Path Trail System of the Morris County Park Commission. (MCPC.)

Whippany River, Morristown, N. J.

The Whippany River is approximately 16 miles long and winds through Morris County before ultimately joining the Rockaway River. Few people realize the importance that Whippany River played in Morristown history. It supplied the water for numerous early businesses in Morristown, from the Revolutionary War–era Ford Powder Mill to Speedwell Iron Works. It was also an important source of water for the paper plants in nearby Whippany. The river lent its name to the Whippany River Railroad. For generations of Morristown children, it was the local swimming hole. Today, the river can be accessed by the public along the Morris County Park Commission's Patriot's Path system of trails.

Along the Whippany River, Morristown, N. J.

Falls at Pocahontas Lake, Morristown, N. J.

As seen in this early-20th-century image, Lake Pocahontas was popular with children who may have been from the nearby enclave of Italian immigrants on Flagler Street. Early congregants from the Church of God of Christ used it for baptisms. The Delaware, Lackawanna & Western Railroad roundhouse was located on the eastern shore of the lake. Historically, the lake powered local businesses, including a gristmill, a paper mill, and a brickworks.

Ten
RESIDENTIAL STREETS

An aerial view from St. Peter's tower looking toward Maple Avenue is a good starting point for an exploration of Morristown's residential neighborhoods. Although Morristown is most known historically for the role it played in the Revolutionary War, most of its current historic structures date from the Victorian era. The elegant homes seen here are typical of what could be found on many of the residential streets depicted in the following images.

South Street begins at the Morristown Green and continues south across Route 287 and past Seaton Hackney Farm, heading toward Harding. Today, little of South Street north of the highway is residential. During the 19th century, it was mostly a residential district past the intersection of Miller Road, with one notable exception being the carriage shop of Lewis Pierson Jr. on the corner of Madison Street. The estates of Richard McCurdy, George Jenkins, and William Skidmore occupied substantial acreage. In between the elaborate estates were the Morristown Club, an exclusive private men's club across the street from the church; Miss Dana's School for Girls, situated near the intersection of Madison Avenue; and the Morristown Field Club.

Today, Madison Avenue is marked by medical buildings and office complexes. In 1910, however, it was one of the grandest streets in America, comparable to Newport, Rhode Island, in wealth of the occupants. Names like Mellon, Colgate, Ballantine, and Twombly had lavish estates here. The gentleman on the right in this image may have been one of the numerous servants who shared the address only as a workplace.

Jefferson Avenue intersected with Madison Avenue roughly where Morristown Medical Center is today. As seen in this image, there were a number of large residences along this stretch of Madison Avenue, mostly built in the first decade of the 20th century. Today, this stretch of road is occupied by numerous medical buildings associated with the hospital. (Lewis Feldman.)

Maple Avenue is one of Morristown's streets that combine commercial and residential properties. At the James Street end is Assumption Church, which marked the center of the Little Dublin neighborhood of Irish immigrants. Moving northward, there are Victorian houses dating from the 1850s through the 1870s. Originally residences, many of these are now used as office buildings. Maple ends at Market Street, with 1 Maple Avenue occupied by Morristown's first green building.

Boyken Street, now known as Miller Road, originally ran from South Street to Macculloch Avenue. In 1889, the street was extended; the section below Macculloch became known as Miller Road, and the original section retained the name Boyken. With a few exceptions, the street retains much of its 19th-century flavor, starting between the Morristown Library and St. Peter's Church and ending at Ogden Place.

Headley Road, a relatively short road off of South Street, was established in the late 19th century. In the first decade of the 20th century, several large homes in the Colonial and Tudor Revival styles were built. Even though it is near the hustle and bustle of downtown Morristown, it remains a tree-lined residential street with many of the early-20th-century homes still standing.

Elm Street, which runs between South and Morris Streets, has been a combination commercial and residential neighborhood since the 19th century. The Morris Street end, facing the Morristown train station, was home to C.W. Ennis's lumberyard. From there, Elm became a tree-lined street of Victorian homes ranging in style from Italianate to Gothic Revival and Queen Anne. A handful of those homes still stand today, most as offices. (Lewis Feldman.)

This image is of Morris Avenue past Washington's Headquarters. Morris is an 18th-century road headed toward Madison and Whippany; its homes date mostly from the 1920s through the 1940s, with a few earlier dwellings. On the far right of the image, a Tudor-style home is just visible. The house, located at 25 Morris Avenue and still standing today, is set back from the road with a large front lawn. (Lewis Feldman.)

Whippany Road derives its name from literally being the road to Whippany, New Jersey. Emanating from the intersection of Columbia Turnpike, Lafayette Avenue, and Morris Avenue, today it ends at Route 10. Whippany Road passes through a small community known as Monroe, which is in both Morris and Hanover Townships just past the entrance to Route 24. Sadly, many of the beautiful homes that once occupied Whippany Road, including the Fairholme estate, have been torn down.

Bibliography

Cavanaugh, Cam. *In Lights and Shadows: Morristown in Three Centuries.* Morristown, NJ: The Joint Free Public Library of Morristown and Morris Township, 1994 ed.

Cunningham, John T. *The Uncertain Revolution: Washington and the Continental Army at Morristown.* West Creek, NJ: Cormorant Publishing, 2007.

———. *Youth's Bright Years: An American High School, Morristown, New Jersey.* Morristown, NJ: The Morris Educational Foundation, 1999.

DeGraaf, Anne and others. *Washington's Headquarters Museum, Morristown National Historical Park.* Lawrenceburg, IN: The Creative Company, 2007.

Hoskins, Barbara. *Morris Township, New Jersey: A Glimpse into the Past.* Morristown, NJ: The Joint Free Public Library of Morristown and Morris Township, 1987 ed.

Rae, John W. *Morristown's Forgotten Past, "The Gilded Age."* Morristown, NJ: J.W. Rae, 1979.

Sherman, Andrew. *Historic Morristown, New Jersey: The Story of Its First Century.* Morristown, NJ: The Howard Publishing Company, 1905.

Simon, Richard C. *The Green: A History of Morristown Green.* Morristown, NJ: The Trustees of the Morristown Green, Inc., 2004.

Turkington, Cheryl C. *Greeting the Past: A Walking Tour of the Dublin Neighborhood in Morristown, New Jersey.* Morristown, NJ: Morristown & Morris Township Library, 2006.

Discover Thousands of Local History Books
Featuring Millions of Vintage Images

Arcadia Publishing, the leading local history publisher in the United States, is committed to making history accessible and meaningful through publishing books that celebrate and preserve the heritage of America's people and places.

Find more books like this at
www.arcadiapublishing.com

Search for your hometown history, your old stomping grounds, and even your favorite sports team.

Consistent with our mission to preserve history on a local level, this book was printed in South Carolina on American-made paper and manufactured entirely in the United States. Products carrying the accredited Forest Stewardship Council (FSC) label are printed on 100 percent FSC-certified paper.

MADE IN THE USA